<u>DiGi+AL +YPE</u>

Rockport Publishers, Inc. Rockport Massachusetts

Copyright © 1997 Rockport Publishers, Inc.

All rights reserved. No part of this book may be

reproduced in any form without written permission of

been reproduced with the knowledge and prior consent

the contents of this publication. Every effort has been

made to ensure that credits accurately comply with

the copyright owners. All images in this book have

of the artists concerned and no responsibility is

accepted by producer, publisher, or printer for any infringement of copyright or otherwise, arising from

Distributed to the book trade and art trade in the United States by: North Light, an imprint of F&W Publications 1507 Dana Avenue

Cincinnati, Ohio 45207

Telephone: (800) 289-0963

Other Distribution by: Rockport Publishers, Inc. Rockport, Massachusetts 01966-1299

ISBN 1-56496-259-8 First published in the United States of America by:

10 9 8 7 6 5 4 3 2 1

Rockport, Massachusetts 01966-1299

Designer: Stoltze Design

Telephone: (508) 546-9590

Fax: (508) 546-7141

Rockport Publishers, Inc.

information supplied.

146 Granite Street

Printed in Hong Kong

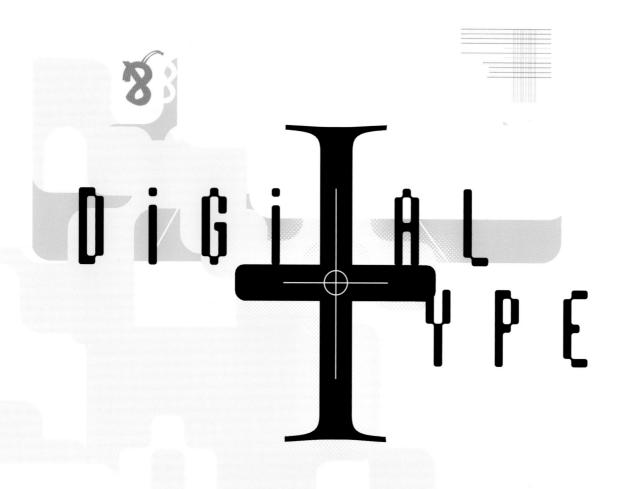

introduction

The digital age has forever changed the visual landscape of graphic design. It has enabled the designer to try more ideas more quickly, and produce more complex and personalized solutions. Most notably, it has empowered designers to create their own images rather than relying solely on photographers or illustrators. Type itself can become the illustrative element.

Type as image—or in combination with other images—is nothing new. But today, with the utilization of drawing programs such as Adobe Illustrator and Photoshop as well as 3-D rendering programs such as Typestry, typography has become more alive than ever.

Rules have changed. The recent proliferation of computer-generated typefaces has eliminated the "safe list" of fonts from which designers should choose. Now there are literally thousands of type-faces and effects available which can combine to create millions of options. The challenge is to weed through the morass and arrive at the optimal solution without spending an eternity exploring different design possibilities.

This collection of recent work, submitted by designers from around the world, showcases a cross-section of projects which incorporate digital type that has either been designed or manipulated on the computer and used as a prominent aspect of the design. The examples range from highly personal work to more commercial projects with a specific message directed towards a broad audience.

Eliot Earl and Stephen Farrell represent a new breed of type designers whose promotional pieces uniquely capture the eclectic and surprisingly beautiful qualities of their fonts.

Carlos Segura masterfully integrates typefaces from his own foundry with real projects for business and culture reworking the modernist ethic into a truly contemporary hybrid of form and function.

Shuichi Nogami's letterform explorations do not use fonts at all. By combining different photographic images in Adobe Illustrator and Photoshop, Nogami creates formally stunning abstract letterforms.

Paula Scher's work for the Public Theater in New York lives in the culture of the street. The graffiti-influenced layouts are alive with the dramatic interplay of type and image, and evoke early woodcut advertisements from the beginning of the century.

The diversity of this collection clearly demonstrates that the use of the computer in design has evolved from a lumbering typesetting tool with its own techno-primitive aesthetic to a fast, sophisticated means of achieving a multitude of imaging tasks that no longer reveal the high tech process or origins.

As technology develops constantly, the full potential of digital typography grows exponentially. But as evidenced in this book, we always come back to the basic principles that make good design good design whether it comes from a rapidiograph or a Super-Duper Mac 200,000.

-Clifford Stoltze, Stoltze Design

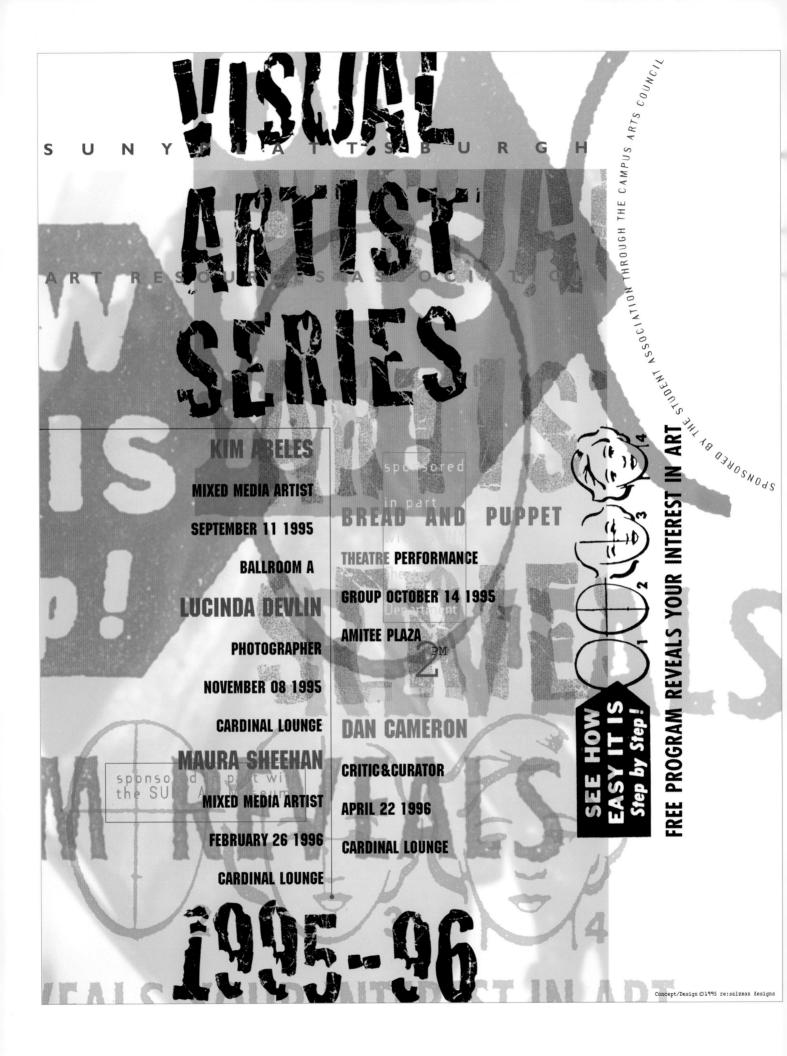

DESIGN Doug Bartow PROJECT Less is Only More in Golf poster TOOL\$ Macintosh FONT Franklin Gothic

This poster uses an image of Mies van der Rohe asleep on a park bench to question his overquoted statement, "Less is more." The designer sought to activate the space to emphasize this point.

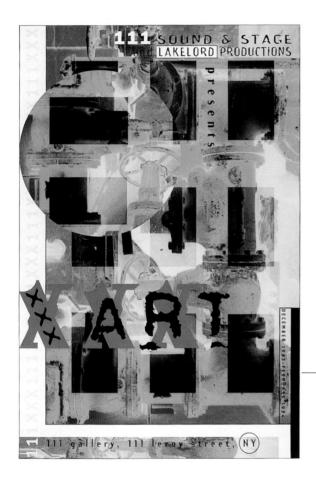

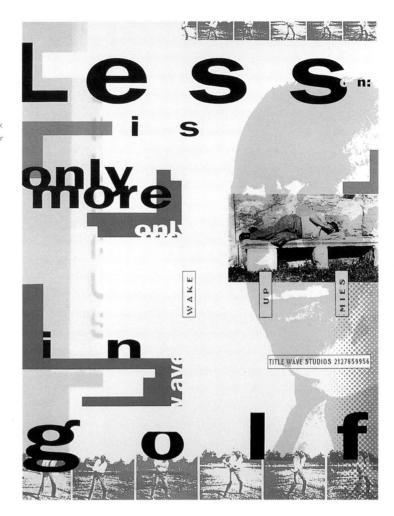

DESIGN Norman Moore for Design Art, Inc. PROJECT Lakelord poster CLIENT 111 Sound and Stage TOOL\$ Adobe Photoshop, QuarkXPress on Macintosh FONT Archaos, Caustic Biomorph

This is a **poster** for an art show.

DESIGN Rick Salzman for re: salzman designs PROJECT '95-'96 Visual Artist Series poster CLIENT SUNY Plattsburgh Art Department TOOL\$ FreeHand on Macintosh FONT Crack House Xerox Distressed

The '95-'96 Visual Artists Series poster is an annual series sponsored by college art students. This year's theme was a pun of the comic book ads challenging readers to test their artistic abilities. The background is a blurred photo of a student's metal sculpture.

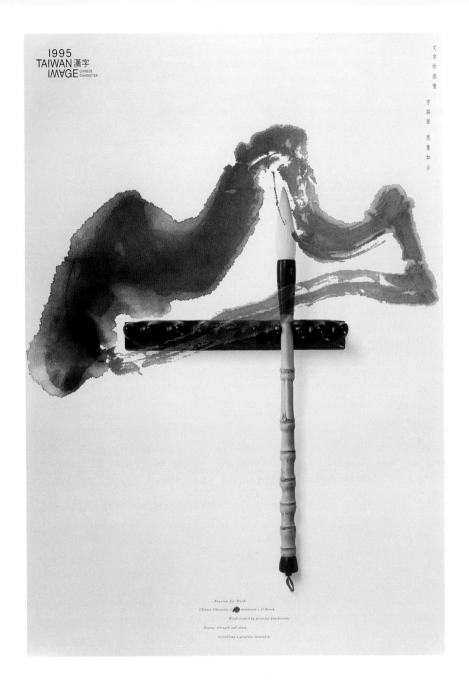

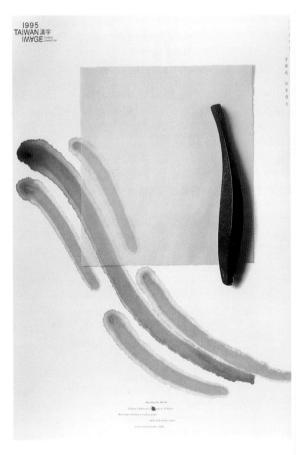

DESIGN Kan Tai-keung and Veronica Cheun Lai Sheung for Kan Tai-keung Design and Associates, Ltd.

PROJECT 1995 Taiwan Image - Chinese character (mountain, water, wind and cloud)

T ○ ○ L \$ FreeHand, Adobe Photoshop

This is a set of four posters specially **designed** for an invitation show. Chinese calligraphy and traditional stationery show the **artistic and sentimental side of the Chinese character.**

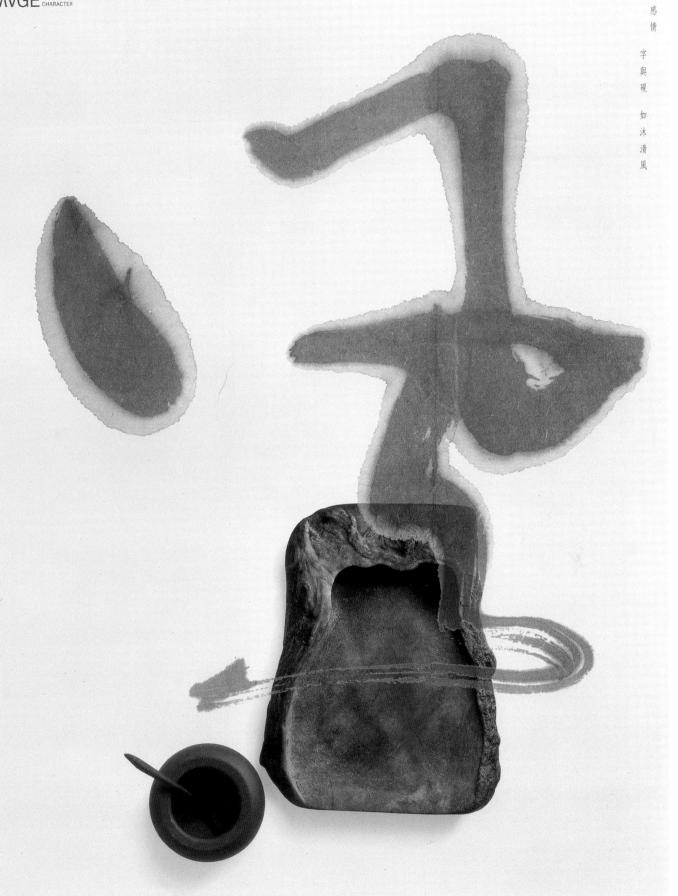

文字的

Passion for Words

Chinese Character (wind) 3 Inkstone

The twirling movement of ink on inkotone

creates a feel of

brisk, delightful wind.

ESIGN PART 1 ► SHINNOSUKE SUGISAKI / KEN MIKI < 3.1 - 3.18 > PART 2 YOSHIMARU TAKAHASHI / TOSHIYASU NANBU < 7.4 - 7.16 > PART 3 ► KAZUAKI OHARA / SHUICHI NOGAMI < 10.18 -10.29 > PLACE FOSAKA CONTEMPORARY ART CENTER GRAPHIC SPACE

DESIGN Shuichi Nogami for Nogami Design Office

CLIENT Osaka Contemporary Art Center

 $^{\intercal}$ $^{\circ}$ $^{\circ}$ $^{\circ}$ Adobe Illustrator, Adobe Photoshop on Macintosh

FONT Franklin Gothic Demi

DESIGN Tony Klassen for Segura, Inc.

PROJECT MRSA

CLIENT MRSA Architects

TOOLS Adobe Photoshop on Macintosh

Mata [T-26] Font

This is an **illustration** of key words **altered** in Photoshop for a poster and mouse pad.

DESIGN Robert Bak for Robert Bak PROJECT Bullet Proof Space

TOOL\$ FreeHand, Adobe Illustrator, Adobe Photoshop, Kai's Power Tools on Macintosh

FONT Empire BT

The type was made in FreeHand and **exported** as an Adobe Illustrator file. The $typographic\ layout$ was also prepared in FreeHand. The backgrounds were designed in Photoshop with KPT filters.

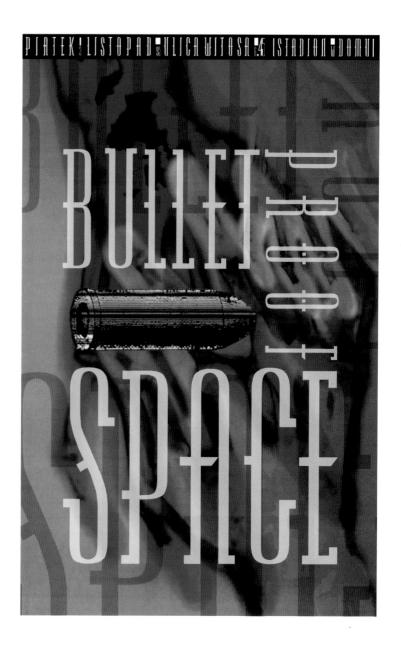

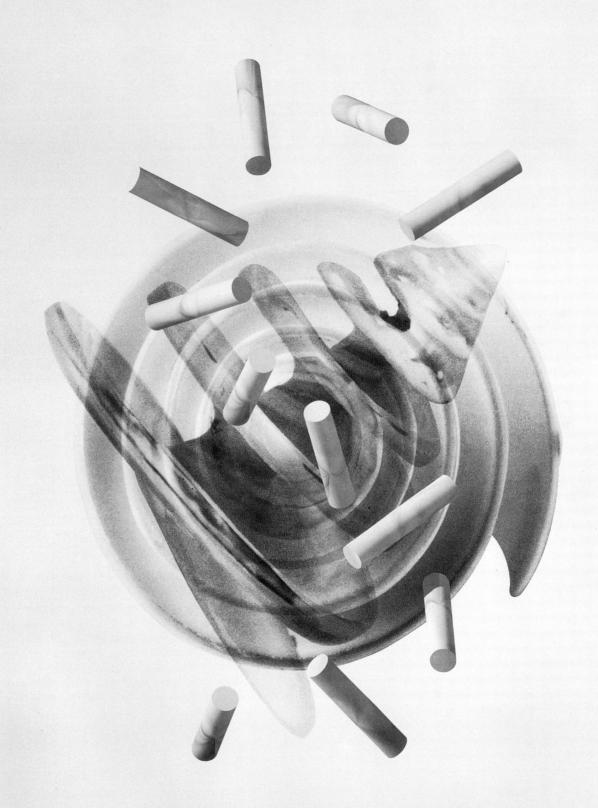

しろもの:ホワイト
OK MUSE SHIROMONO WHITE

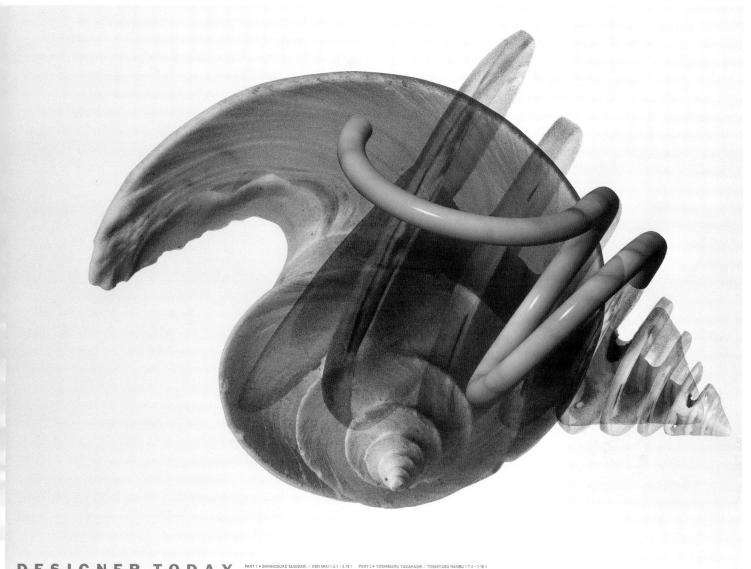

DESIGNER TODAY

D E \$ ו G N Shuichi Nogami for Nogami Design Office ¢ L I E N Т Osaka Contemporary Art Center TOOLS Adobe Illustrator, Adobe Photoshop on Macintosh

The letter ${\it D}$ is **expressed through the combination** of different photographic images.

DESIGN Shuichi Nogami for Nogami Design Office CLIENT New OJI Paper Co., Ltd. TOOL\$ Adobe Illustrator, Adobe Photoshop on Macintosh

The letter O was **expressed through the shapes** of the photograph in the design.

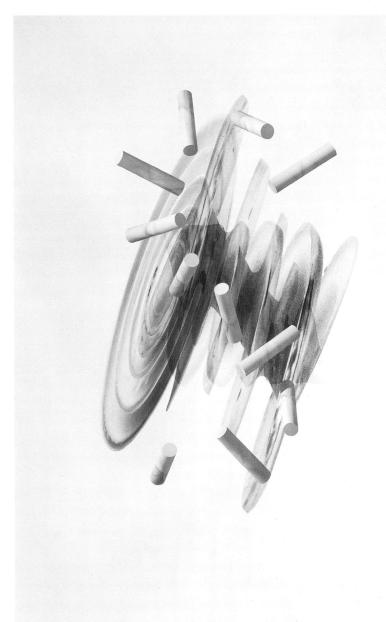

しろもの:ホワイトN

新王子製銀株式会社

DESIGN Shuichi Nogami for Nogami Design Office ¢ L I E N T New OJI Paper Co., Ltd. $^{\text{T}} \circ \circ ^{\text{L}}$ Adobe Illustrator, Adobe Photoshop on Macintosh

The placement of the ${\tt photographic}$ images ${\tt reveals}$ the letter ${\tt N}.$

DESIGN Shuichi Nogami for Nogami Design Office CLIENT New OJI Paper Co., Ltd. TOOL\$ Adobe Illustrator, Adobe Photoshop on Macintosh

The letter S is **expressed through** the use of photographic images.

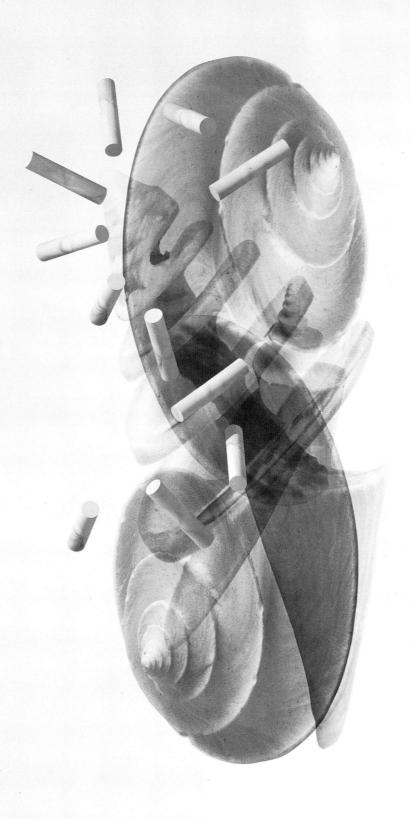

しろもの:ホワイトS OK MUSE SHIROMONO WHITE S

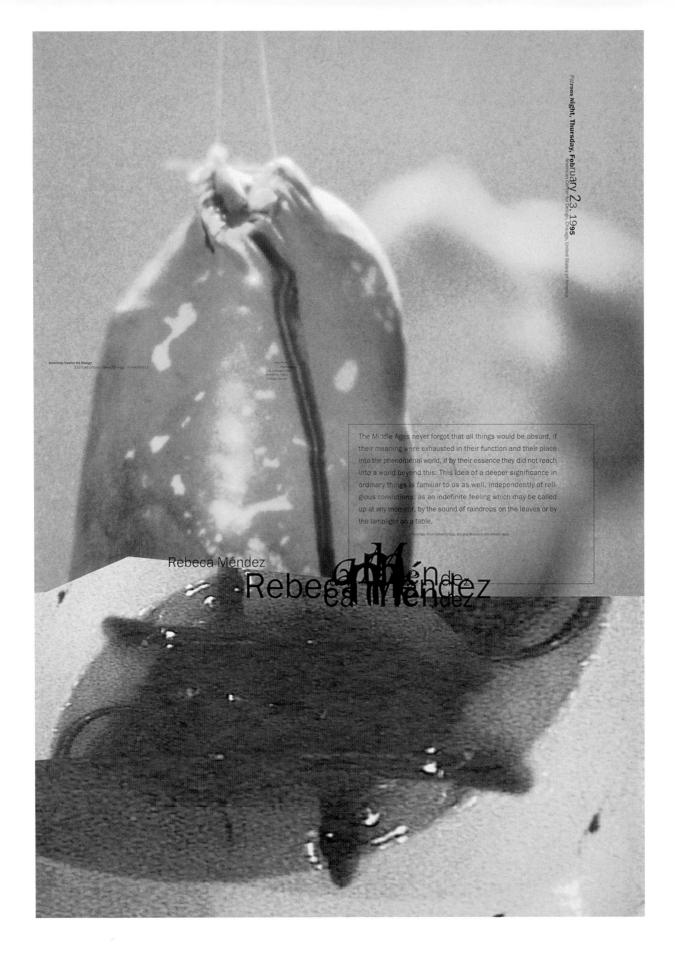

D € \$ 1 G N Rebeca Méndez for Rebeca Méndez Design American Center for Design FONTS Perpetua and Franklin Gothic

The designer presented her design and art work for the ACD in Chicago. The poster includes imagery from fine art videos, installations, and letterpress work. The focus is the construction and deconstruction of identity through boundaries, both at an individual and at an institutional level.

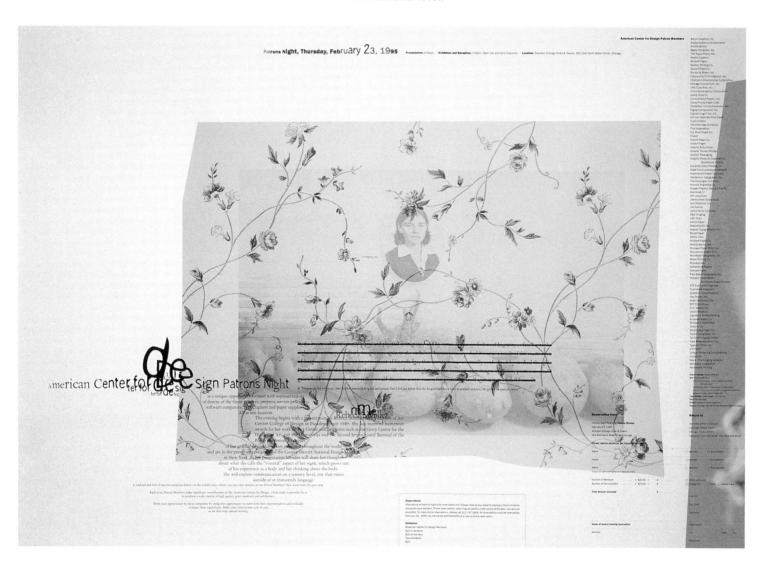

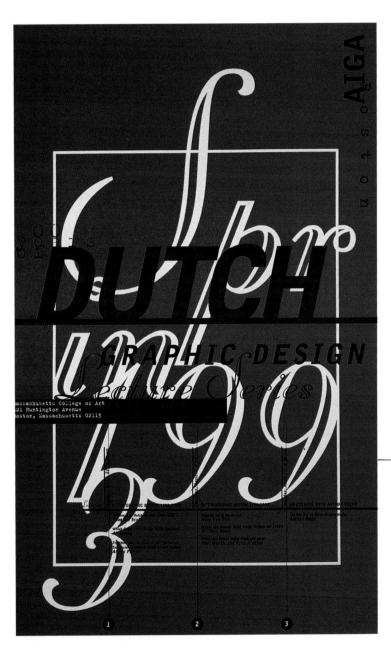

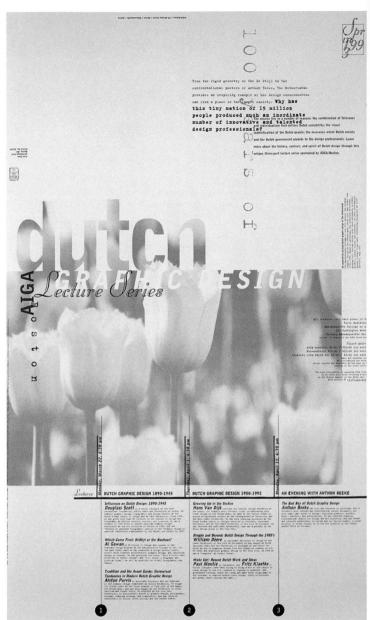

DESIGN Clifford Stoltze for Stoltze Design Dutch Graphic Design ↑°°L\$ AIGA-Boston FONT\$ Stuyvesant, Monotype Black, and Trixie

> The contrast between a script (Stuyvesant), a sans serif (Monotype Black), and a typewriter font (Trixie) represents the multiplicity of the Dutch design scene.

DESIGN Deborah Littlejohn

PROJECT CalArts Poster and Mailer

CLIENT California Institute of the Arts

TOOLS Adobe Photoshop on Macintosh

FONTS Data, Hubba Bubba

This poster is meant to represent an **electrically charged** atmosphere (CalArts) that emits students akin to birthing stars, still **connected to the mother planet by umbilical cords of energy.**

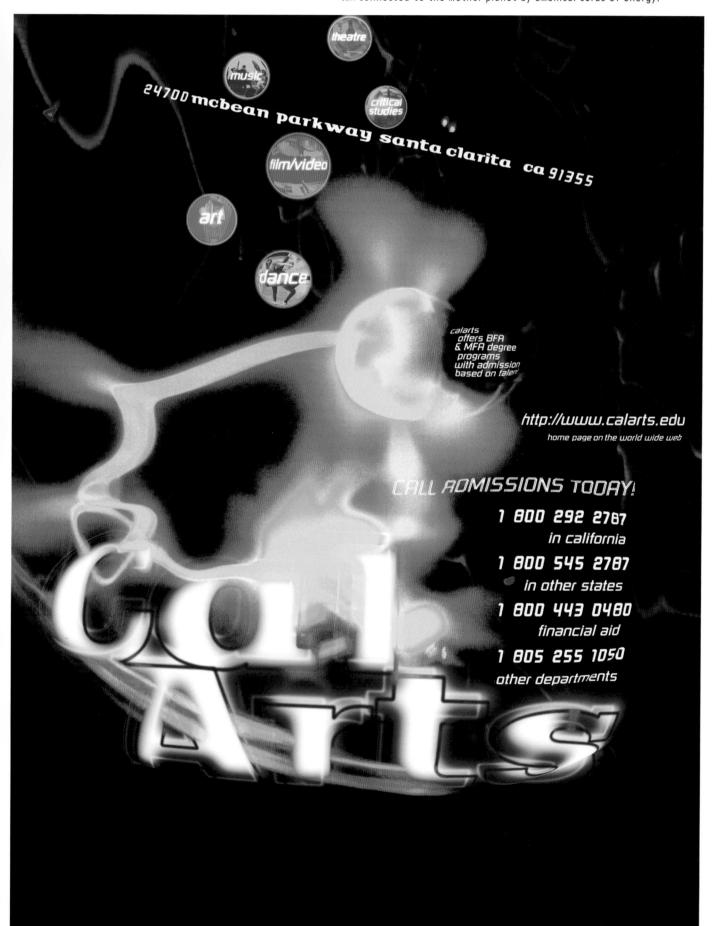

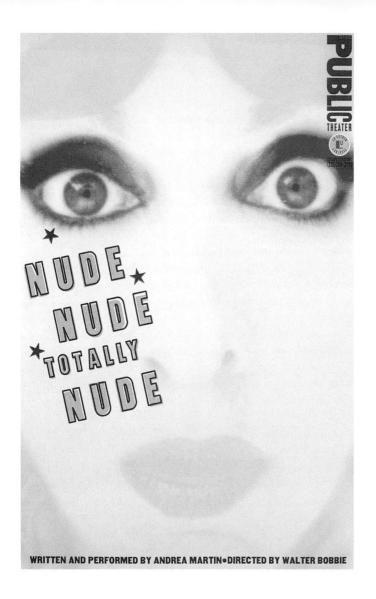

425 LAFAYETTE STREET 212-260-2400

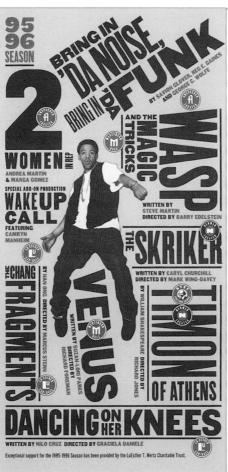

DESIGN Ron Louie, Lisa Mazur, and Paula Scher for Pentagram Design

PROJECT Public Theater poster series

N T Public Theater

FONT\$ Morgan Gothic, Paulawood, Seriwood, E Ten, E Seventeen, E Twentyfive, Wood Block Condensed, Alternate Gothic No. 2

The varied but cohesive graphic language that Pentagram has developed reflects street typography: It's extremely active, unconventional, and almost graffiti-like.

DESIGN Ron Louie, Lisa Mazur, and Paula Scher for Pentagram Designer Opensian Project Public Theater poster series

CLIENT Public Theater

Morgan Gothic, Paulawood, Seriwood, E Ten, E Seventeen, E Twentyfive, Wood Block Condensed, Alternate Gothic No.

The varied but cohesive graphic language that Pentagram has developed reflects street typography: It's extremely active, unconventional, and almost graffiti-like.

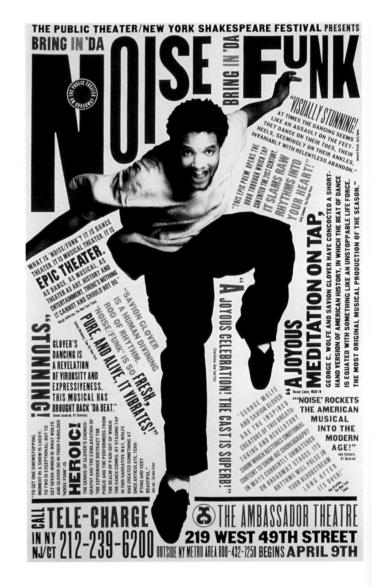

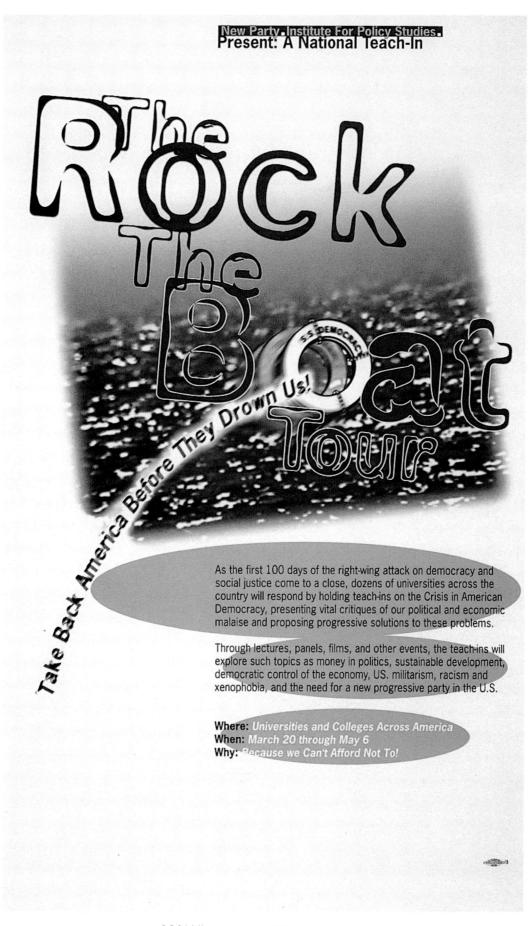

DESIGN Blaine Todd Childers for Todd Childers Graphic Design

PROJECT Rock the Boat poster

CLIENT The New Party

T ○ ○ L \$ Adobe Illustrator, Adobe Photoshop

This poster uses type in a **photographic manner** to suggest a lifesaver **tossed out** to the American public in the wake of a conservative landslide.

DESIGN Elliott Peter Earls for The Apollo Program TOOLS Fontographer, Adobe Photoshop, FreeHand

This is a **series of posters** designed to promote The

Apollo Program's type design.

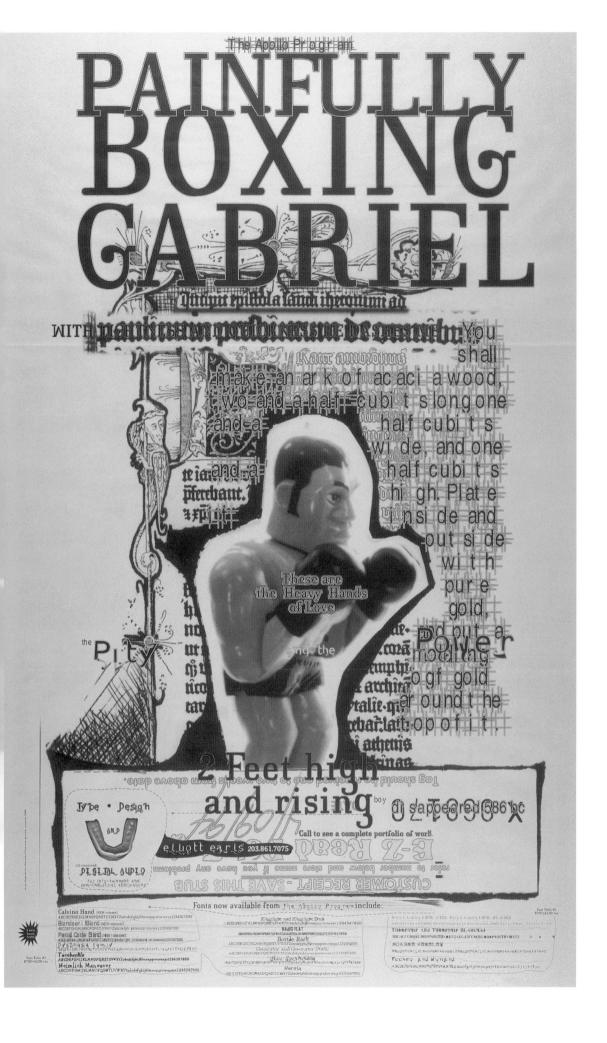

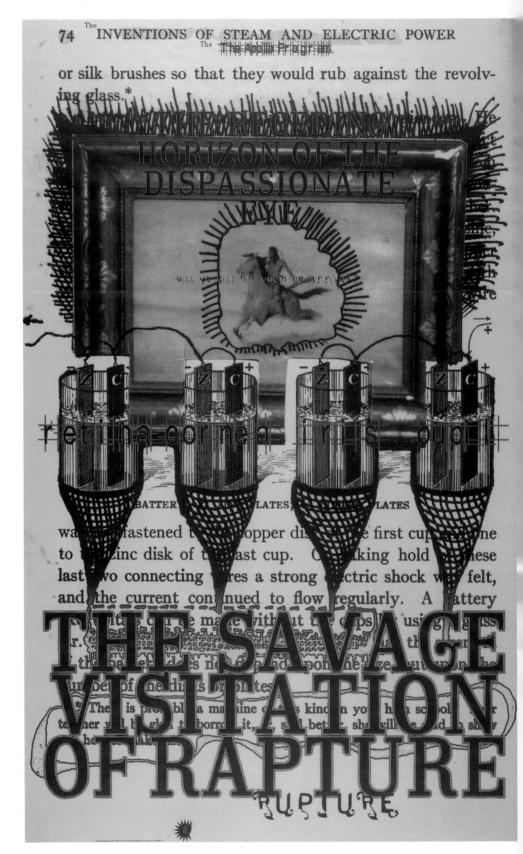

DESIGN Elliott Peter Earls for The Apollo Program TOOL\$ Fontographer, Adobe Photoshop, FreeHand

This is part of a series of posters designed

to promote The **Apollo Program's** type design.

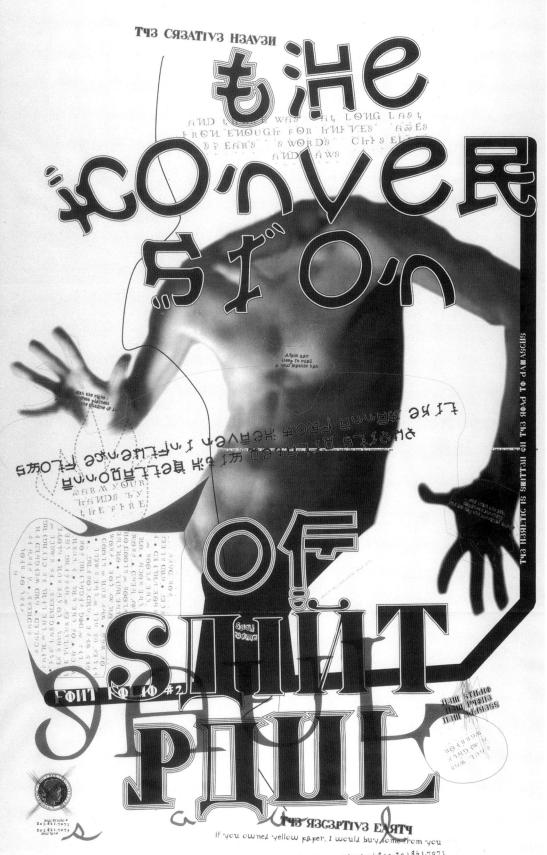

elliott Earls 2 View Street, Greenwhich Connecticut 06330 203.861.7075

 $\underset{\text{Paper}/\text{VENT}}{\text{NouvEau V/TAKEO Co.,Ltd.}} d$

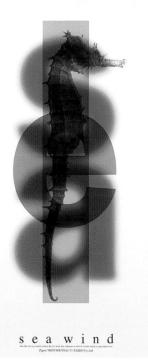

DESIGN Shuichi Nogami for Nogami Design Office CLIENT Takeo Co., Ltd. $au \diamond \circ \iota \diamond$ Adobe Illustrator, Adobe Photoshop on Macintosh FONT Franklin Gothic Demi

The letters in the word "sea" were made to overlap, and the resulting shape was compounded with the photograph.

DESIGN Shuichi Nogami for Nogami Design Office ${\tt CLIENT}$ Japan Graphic Designers Association, Inc. TOOL\$ Strata Studio Pro, Adobe Illustrator, Adobe Photoshop on Macintosh FONT NIL

N is expressed through the design rather than using the letter. The shape and photograph were manipulated to appear as a softened 3-D image.

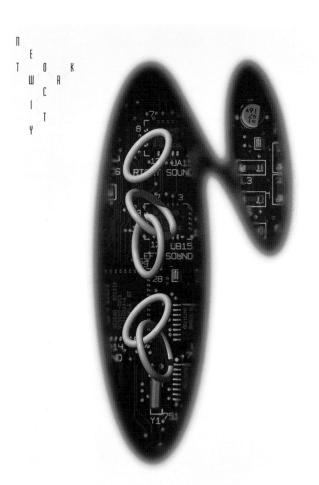

DESIGN Shuichi Nogami for Nogami Design Office CLIENT Takeo Co., Ltd.

 $^{\intercal}$ $^{\diamond}$ $^{\diamond}$ L $^{\$}$ Adobe Illustrator, Adobe Photoshop on Macintosh

FONT Franklin Gothic Demi

Photographic images overlap the letters in the word "sea."

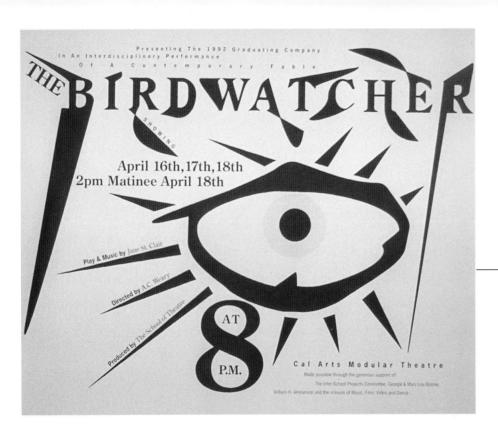

DESIGN James Stoecker

JECT CalArts Theatre poster

^{₹ N T} Theatre Department

τοο∟\$ FreeHand

FONT Century Old Style

The designer **created** this design after reading the script to the play.

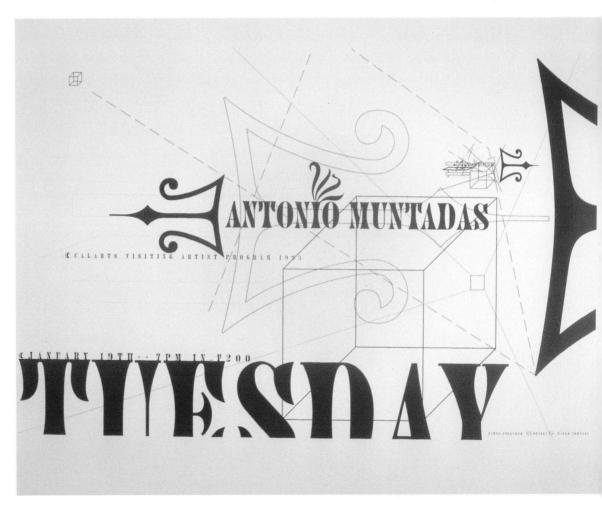

DESIGN James Stoecker

PROJECT CalArts: Visiting Artist poster

CLIENT CalArts Art Department

TOOL\$ FreeHand

FONT Juniper

Humor and seriousness play out in this

environmental artist's work.

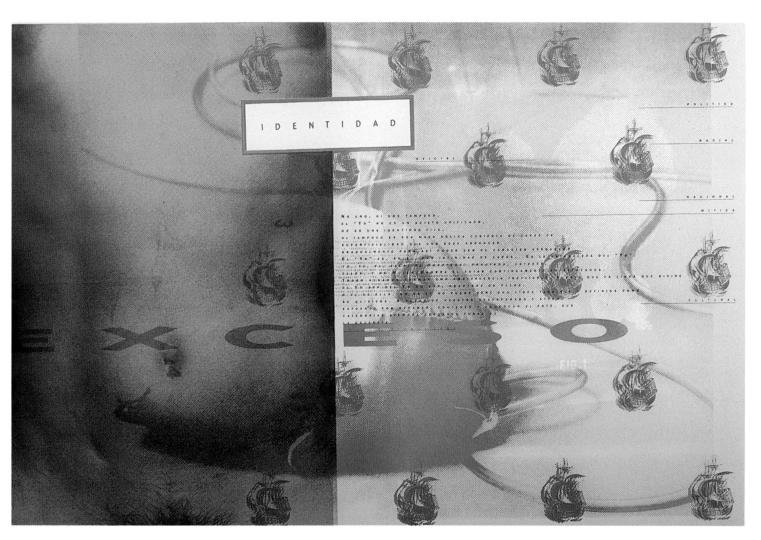

D E S I G N Rebeca Méndez for Rebeca Méndez Design PROJE≎T America Now, 500 Years Later poster CLIENT Second International Biennial of the Poster FONTS Franklin Gothic and Letter Gothic

This poster was created for an international invitational collection for forty posters held in Mexico City. The development of an identity is a very complex process, and any identity, whether is cultural, personal, national, political, or all of them together, is in constant state of change and mutation.

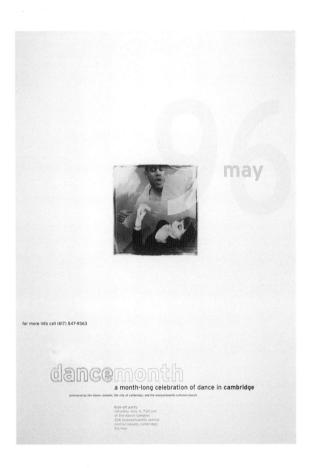

DESIGN Fritz Klaetke for Visual Dialogue CT Dance Month poster series CLIENT Dance Complex TOOL\$ QuarkXPress, Adobe Photoshop, FreeHand on Macintosh FONT Interstate

> In each of the three posters, type and image $\boldsymbol{\alpha re}$ combined in different ways to suggest an abstract choreography.

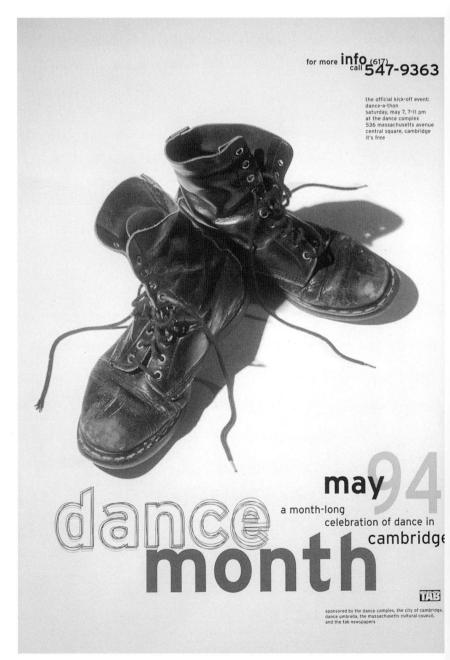

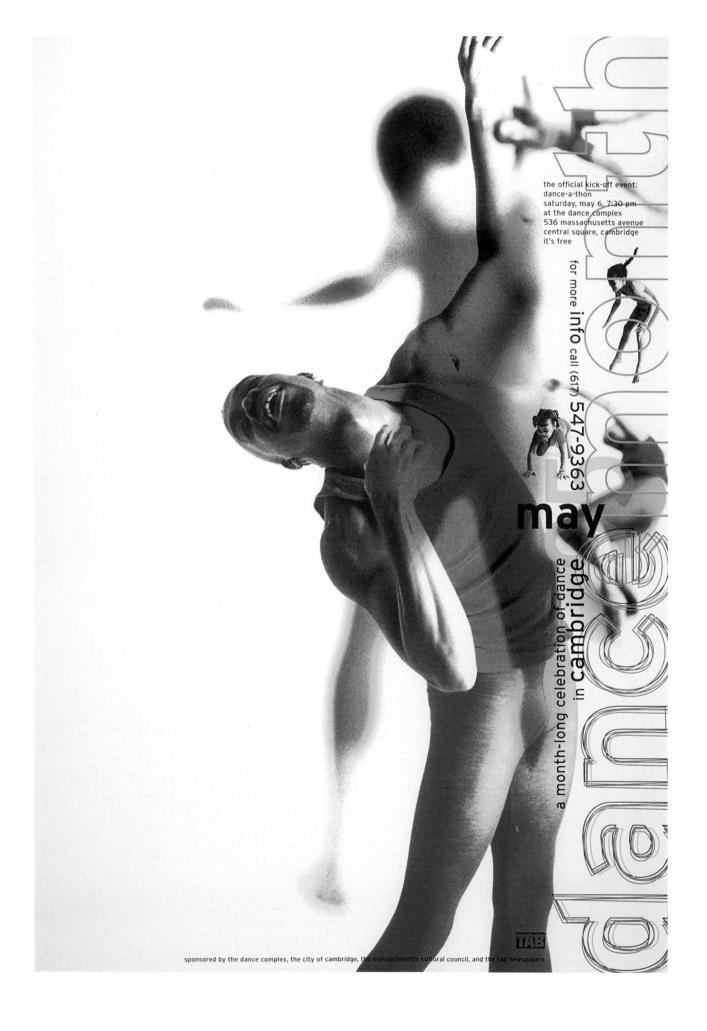

DESIGN Clifford Stoltze and Peter Farrell for Stoltze Design

PROJECT Vaughan Oliver

CLIENT AIGA Boston Chapter

FONTS Scala, Folio, Poster Bodoni

Using images provided by Vaughan Oliver, a poster of seemingly disparate images and typography makes reference to Vaughan's approach to desigThe record "label" design $pays\ homage$ to the vinyl format.

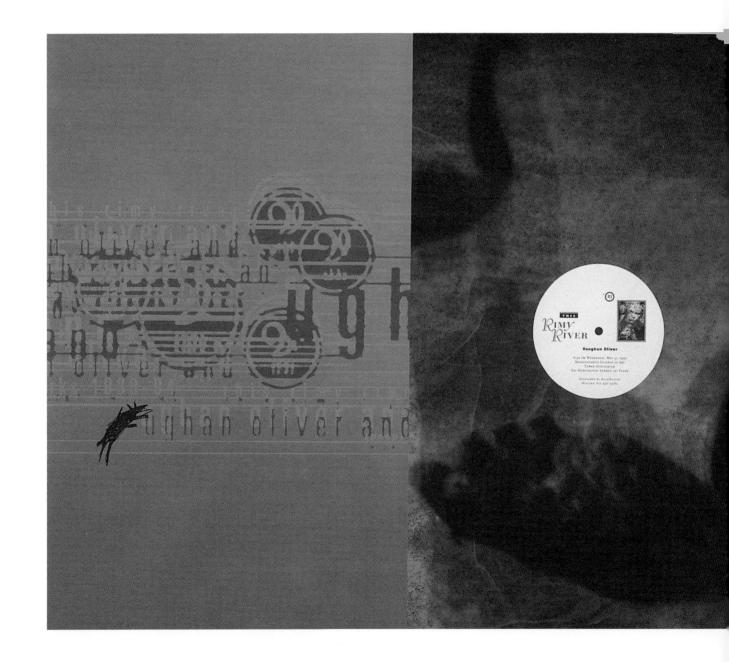

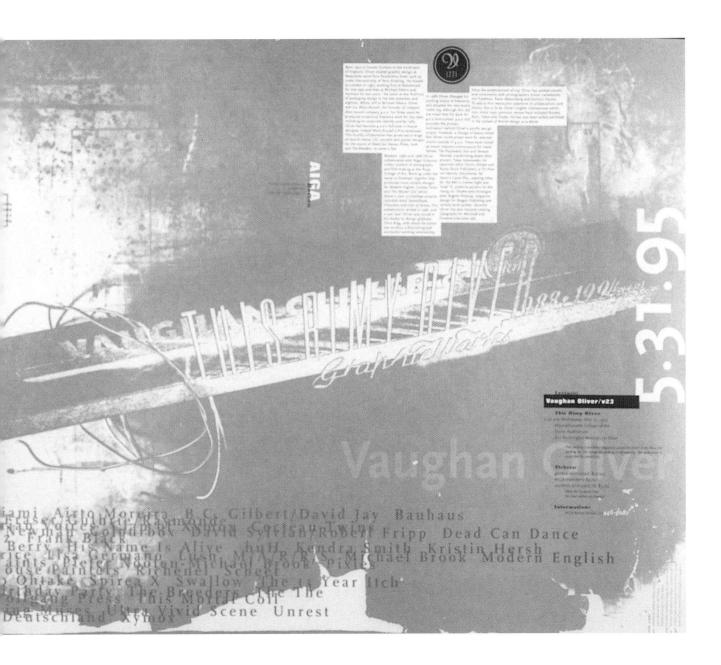

DESIGN Blaine Todd Childers for Todd Childers Graphic Design

PROJECT Dance On the Page

CLIENT CalArts Dance School

^{† o o L \$} | Adobe Illustrator, Adobe Photoshop

This is a cover for a magazine designed for the CalArts Dance School.

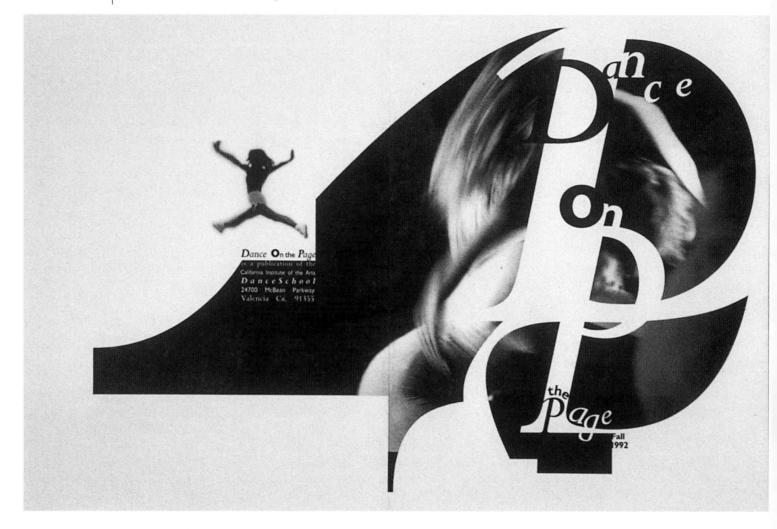

DESIGN Deborah Littlejohn and Shelley Stepp

PROJECT CalArts Spring Dance poster

C LIENT California Institute of the Arts Dance School

 $au\circ L$ \$ Adobe Photoshop, QuarkXPress, FreeHand on Macintosh

РОНТ\$ Perpetua, Cooper Black

The unstructured typography **opposes images** of a traditional dance recital ${\tt performed}$ in the evening hours, ${\tt transforming}$ energy, movement, and structure into chaos.

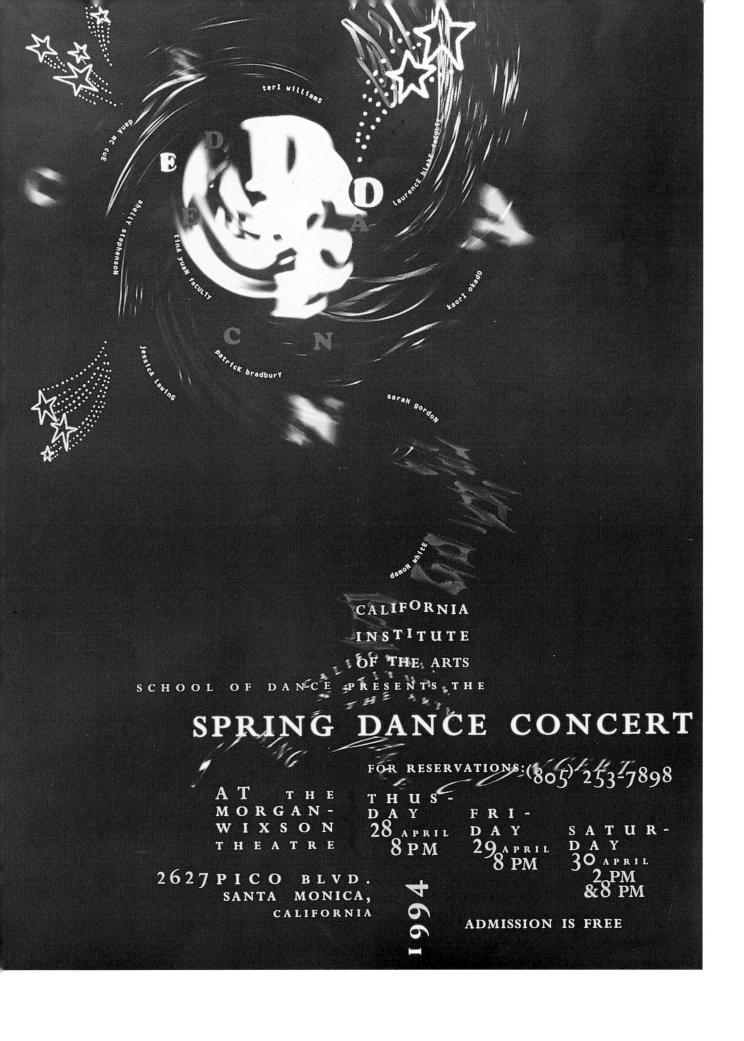

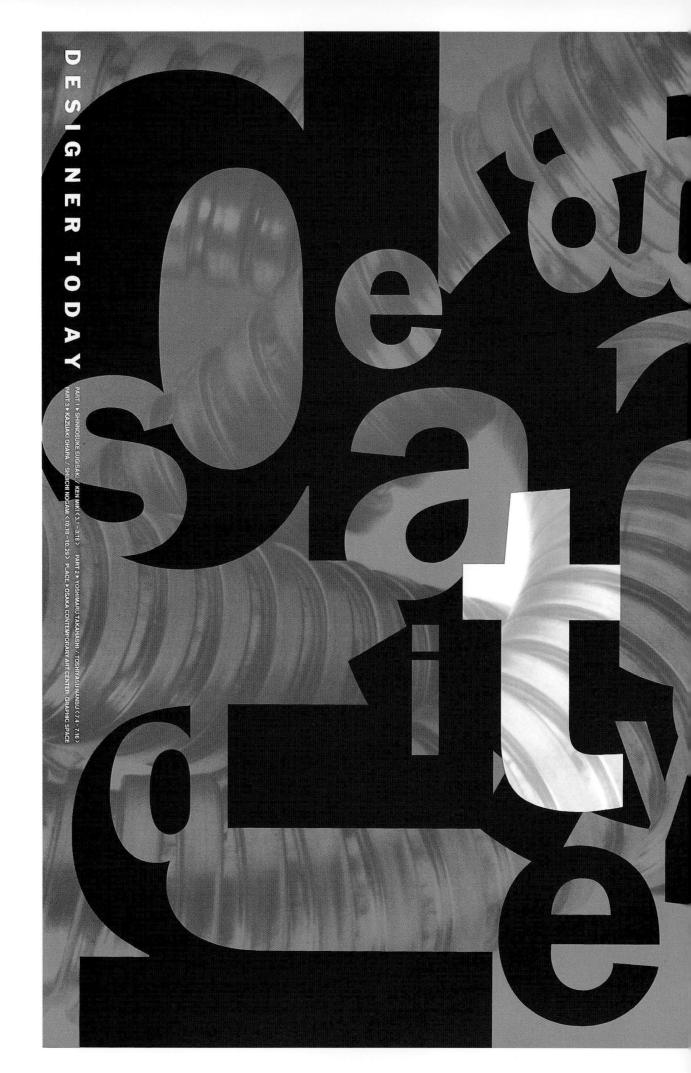

D E \$ 1 G N Shuichi Nogami for Nogami Design Office

CLIENT Osaka Contemporary Art Center

T O O L S Adobe Illustrator, Adobe Photoshop on Macintosh

FONT Franklin Gothic Demi

The letters and the photograph were compounded.

DESIGN Shuichi Nogami for Nogami Design Office CLIENT Osaka Contemporary Art Center

T ○ ○ L \$ Adobe Illustrator, Adobe Photoshop on Macintosh

^{омт} Franklin Gothic Demi

The letter and the photograph were **compounded** for this design.

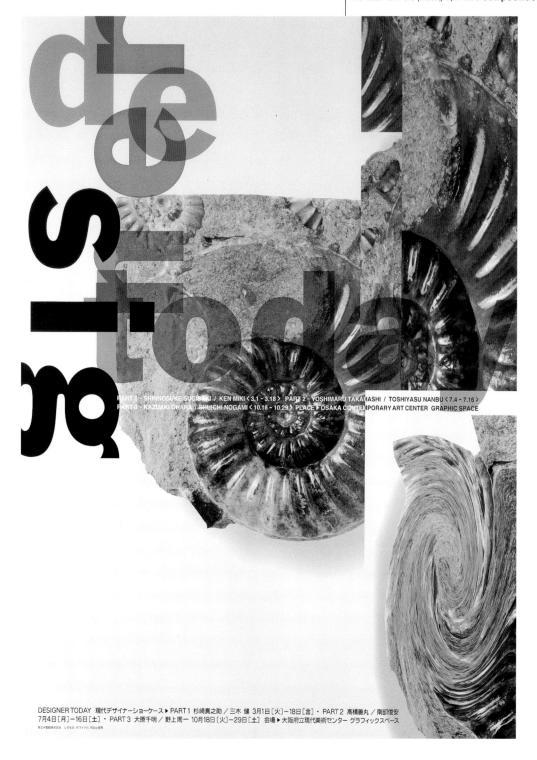

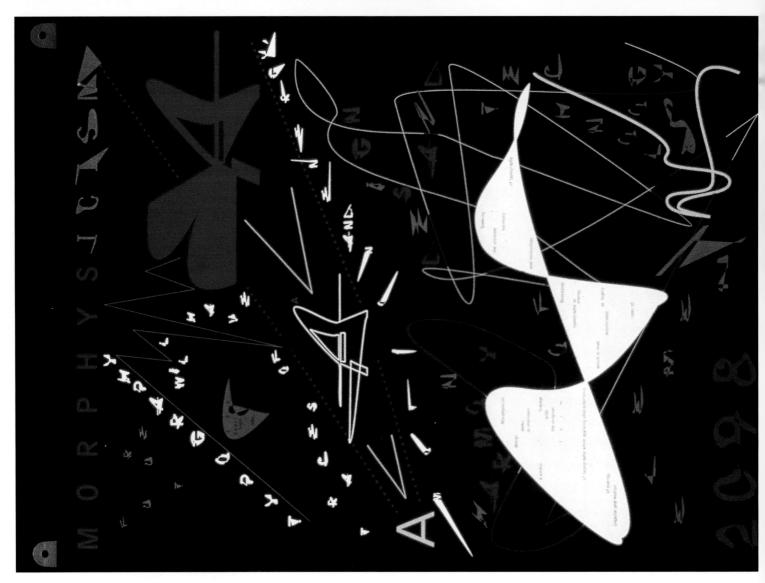

DESIGN James Stoecker

PROJECT CalArts poster: morphysicism personal project with type

TOOL\$ FreeHand

FONT\$ News Gothic, Bell Gothic

This piece was designed to express the fluid dynamics of typography today. It also reflects the information age's impact on design, transmission, transgression, metamorphosis of code, outline, type.

DESIGN James Stoecker

PROJECT Personal Elements of Earth series

TOOL\$ FreeHand, Paste-Up

FONT Futura

One of a series of posters proposed to **create awareness** of the environment conceptually working from definitions and phonetic structure.

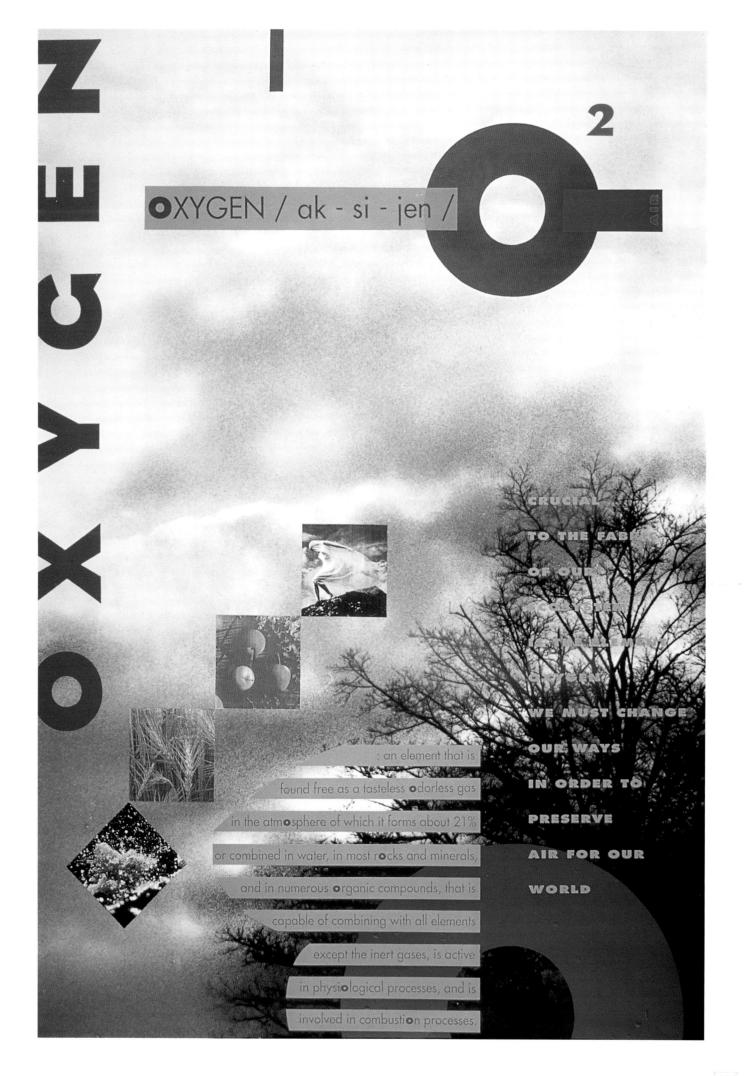

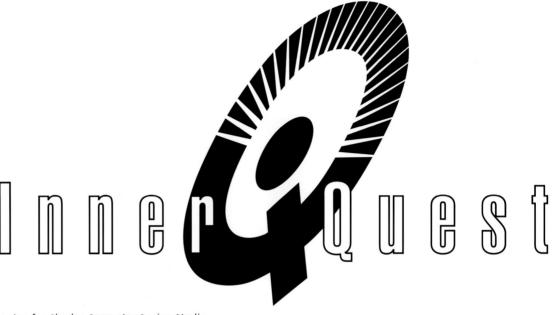

DESIGN Charles E. Carpenter for Charles Carpenter Design Studio

PROJECT Inner Quest logo

CLIENT Inner Quest

TOOL\$ Adobe Illustrator

The designer worked with thumbnails, then on the computer. He tried a ${\bf variety}\ {\bf of}\ {\bf types},\ {\bf which}\ {\bf he}\ {\bf then}\ {\bf converted}\ {\bf to}\ {\bf paths}\ {\bf in}\ {\bf Illustrator}.$ He used distortion to make the shapes he wanted.

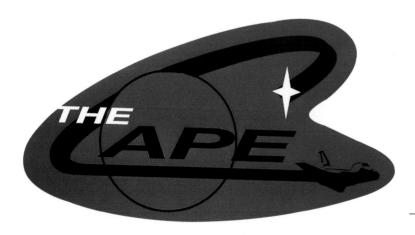

DESIGN Mike Salisbury and Mick Haggerty for Mike Salisbury Communications, Inc.

PROJECT The Cape logo

CLIENT MTM Entertainment

TOOL\$ Adobe Illustrator on Macintosh

This logo was developed for a new television drama focusing on characters involved in space programs.

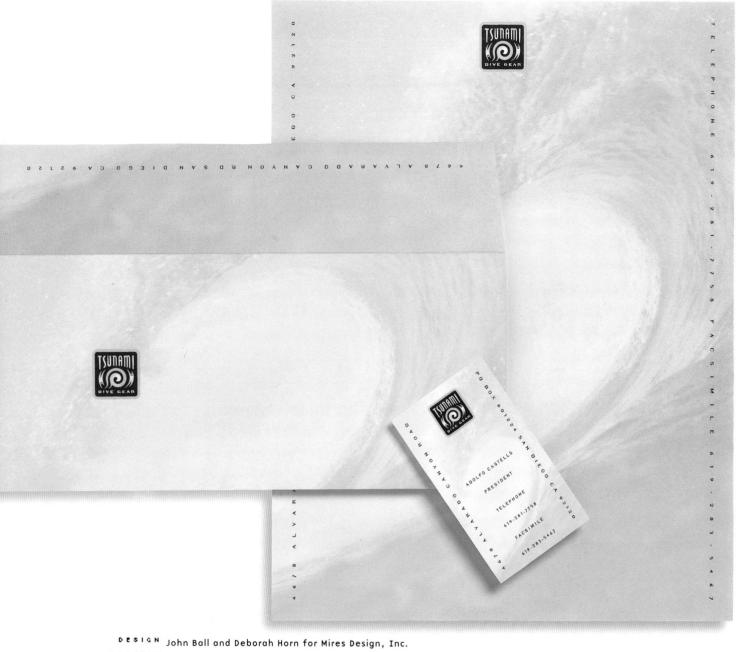

PROJ**E**CT Tsunami logo

CLIENT Tsunami Dive Gear

TOOL\$ Adobe Illustrator on Macintosh

This is a logo for a scuba-diving product line.

DESIGN Meighan Depke and Tony Klassen for Depke Design

CLIENT Planet X

 $^{\text{T} \, \circ \, \circ \, \text{L} \, \$}$ Adobe Photoshop on Macintosh

FONT Industria

This is an illustration of the

Planet \boldsymbol{X} logo for use on business cards and stationery.

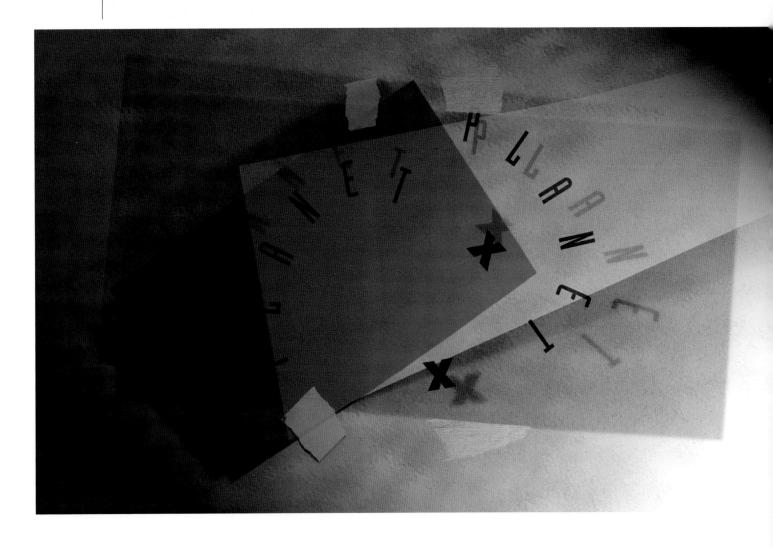

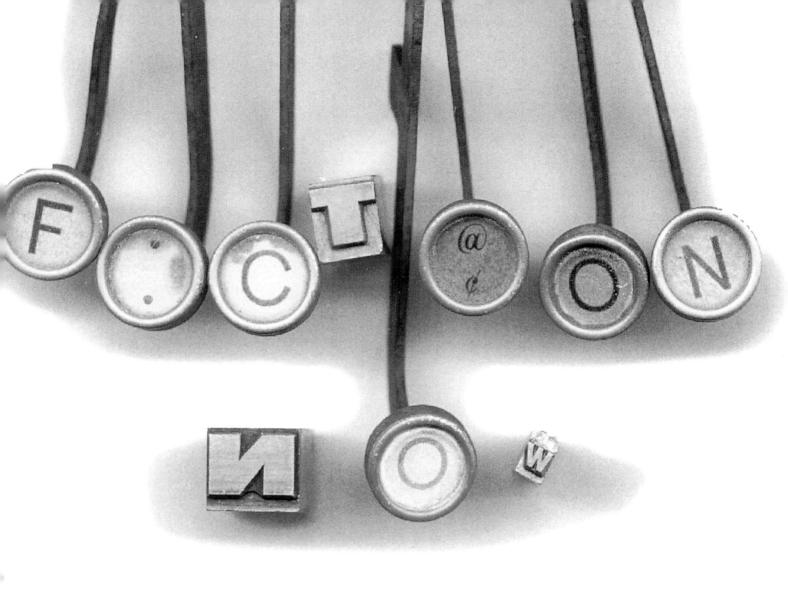

DESIGN Mary Evelyn McGough and Mike Hand for Mike Salisbury Communications, Inc.

PROJECT Fiction Now logo and masthead

¢ L∣ENT Francis Ford Coppola/American Zoetrope

TOOL\$ Adobe Photoshop on Macintosh

 $\mathbf{F} \circ \mathbf{N} \mathbf{T}$ Actual old typewriter keys, Franklin Gothic

Fiction Now is a new writers' journal—a forum for new

writers of short fiction. Old type keys were scanned and manipulated to read as a masthead.

DESIGN Paula Menchen for PJ Graphics TOOLS Adobe Illustrator on Macintosh FONT Borzoi Reader

This is an unrealized logo design that was manipulated and altered in Illustrator. The designer used Borzoi Reader and rescaled and redrew parts of the font.

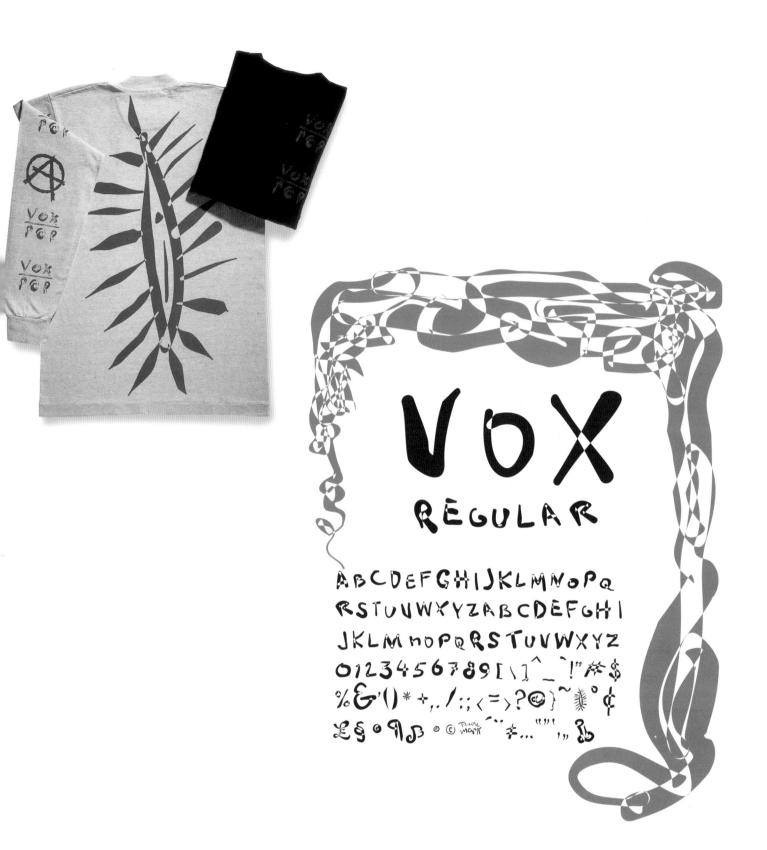

D E \$ 1 G N Giacomo Spazio, Matteo Bologna for Matteo Bologna Design NY/ROM Graphixxx Milano

¢ т Vox Pop corporate identity

Fontographer, FreeHand on Macintosh

FONT Vox (custom made)

The font and the logo were designed with a digital tablet on FreeHand and Fontographer, exploring the possibility of creating shapes with even/odd fills.

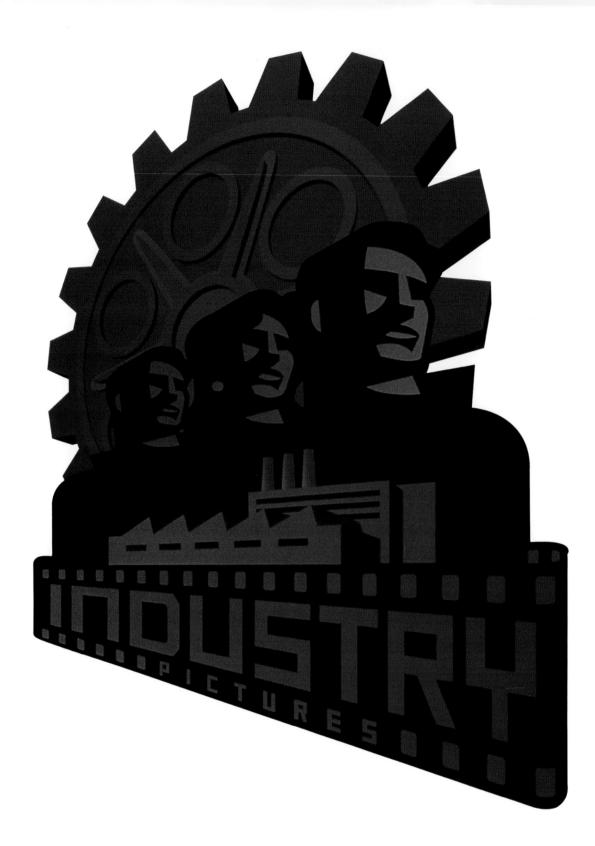

DESIGN Jose Serrano and Tracy Sabin for Mires Design

PROJECT Industry Pictures logo

CLIENT Industry Pictures

 $au \diamond \iota \diamond \iota \diamond$ Adobe Illustrator, Dimensions on Macintosh

FONT Custom Font

This is the **logo** for a corporate-oriented film company.

DESIGN Kathy Carpentier-Moore and John Ball for Mires Design, Inc.

¢ ↑ Industry Pictures logo

CLIENT Industry Pictures

 $^{\intercal \circ \circ L \$}$ Adobe Illustrator on Macintosh

— The designers wanted to capture the 1940s

union worker. The gears, factory, people, and mechanical type all come together to **convey** that feeling.

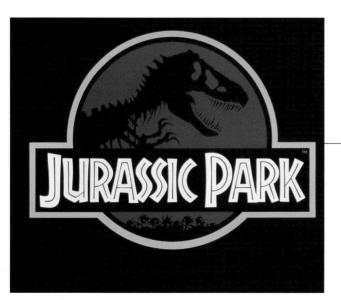

 ${\tt DESIGN}$ Mike Salisbury for Mike Salisbury Communications, Inc.

JECT Jurassic Park logo

CLIENT Universal Pictures

TOOLS Adobe Illustrator on Macintosh

The type from an old sign painter's handbook was scanned and manipulated for this logo.

DESIGN Fritz Klaetke for Visual Dialogue

PROJECT Drawbridge identity

CLIENT Drawbridge

T ○ ○ L \$ QuarkXPress on Macintosh

FONTS Avenir, Courier

— The word "Drawbridge" metaphorically "spans the moat" of confusing and cryptic HTML acronyms.

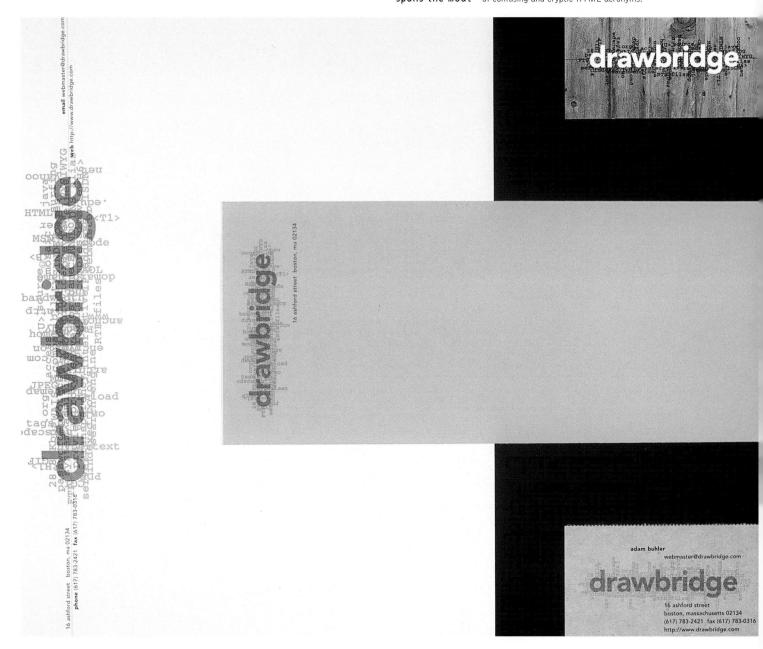

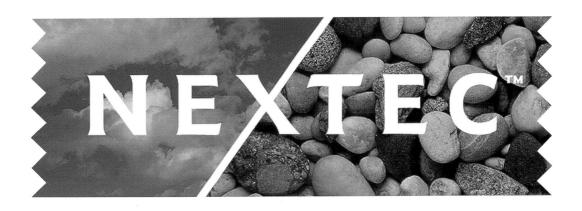

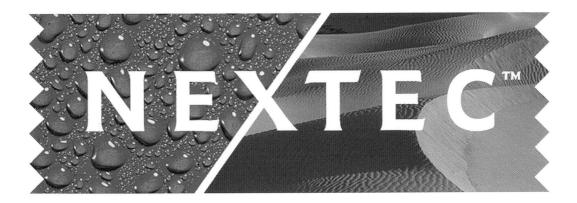

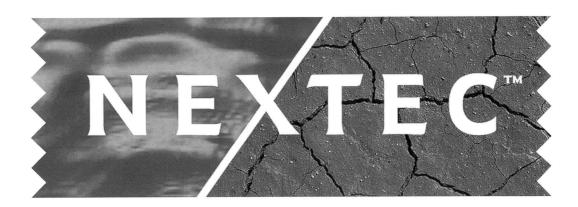

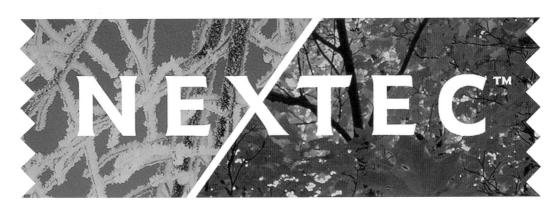

 ${\tt DESIGN}$ Kathy Carpentier-Moore and John Ball for Mires Design, Inc.

PROJECT Nextec logos

CLIENT Nextec Applications, Inc.

 $au\circ L$ \$ Adobe Illustrator, Adobe Photoshop on Macintosh

This is a logo for cold-, heat-, and moisture-resistant fabrics.

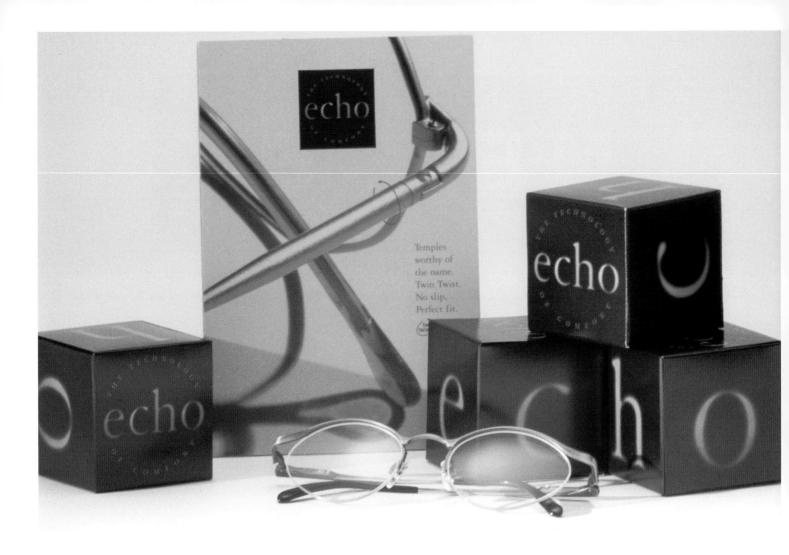

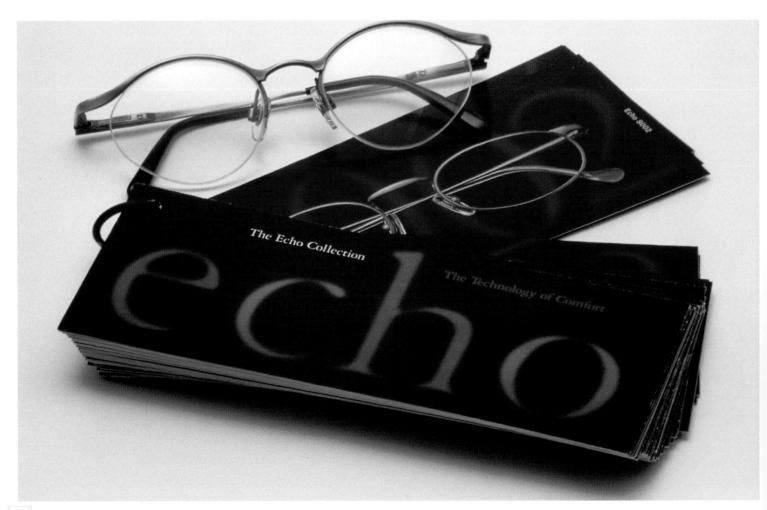

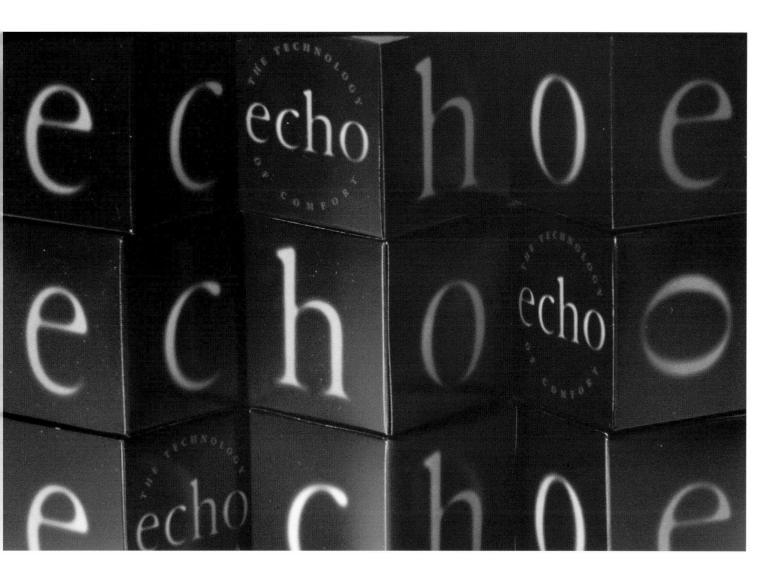

DESIGN Michael Gericke and Sharon Harel for Pentagram Design

PROJECT Echo Eyewear

CLIENT Silhouette Optical

 ${\bf T} \circ \circ {\bf L} \$ Adobe Illustrator, Adobe Photoshop on Macintosh

FONTS Adobe Garamond, Univers

The identity consists of the word "echo" spelled out in diffused type that subtly reverberates against a black background, suggesting the flexible frames. The products were photographed on top of their product numbers, providing easy reference and an interesting backdrop.

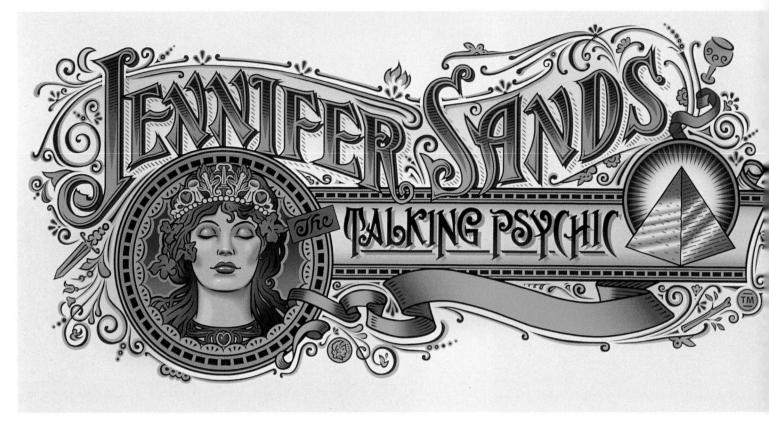

DESIGN Jose Serrano and Tracy Sabin for Mires Design, Inc.

PROJECT Jennifer Sands logo

CLIENT Cranford Street

TOOL\$ Adobe Illustrator on Macintosh

FONT Custom Font

This is the logo for a series of games and household products.

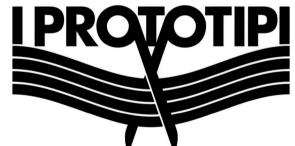

DESIGN Gaetano Ruocco for Graphic Art Studio

PROJECT Logo for hairdresser

CLIENT I Prototipi

 $au\circ L$ \$ Adobe Illustrator, KPT Bryce, Adobe Photoshop on Macintosh

FONT Futura Bold

The designer used Futura because he needed

a simple linear type for the perfect circle of the scissors.

The underline was manipulated to resemble the wave in a hairstyle.

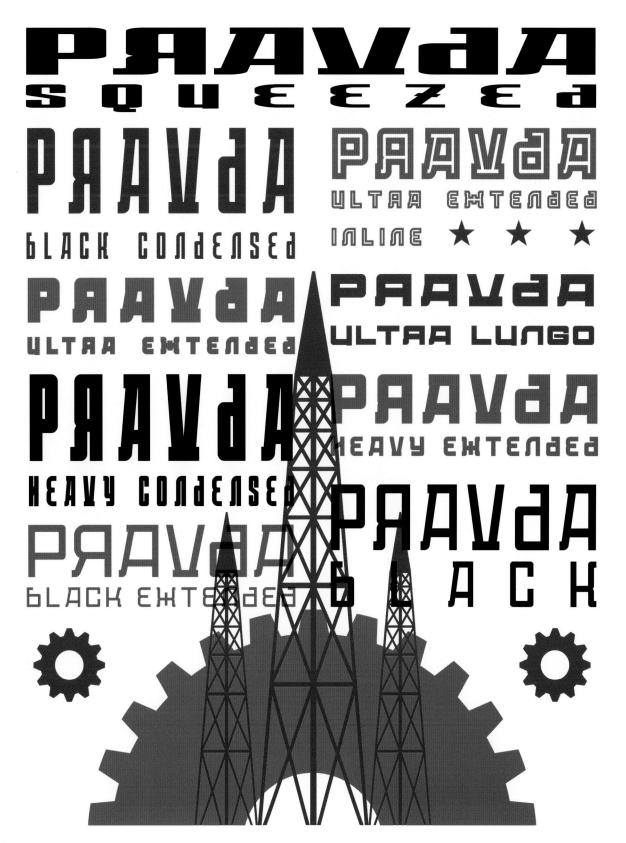

DESIGN Matteo Bologna for Matteo Bologna Design NY

PROJECT Pravda corporate identity

CLIENT Pravda

TOOL\$ Fontographer, FreeHand on Macintosh

 F ○ N T
 Pravda Family (custom made)

The project is a corporate identity for Pravda, a Russian bar in New York. The designers **designed** the font family Pravda (composed of nine different styles). This font was used to define the $\label{eq:neoconstructivist} \textbf{neoconstructivist style} \ \ \text{of the graphic identity}.$

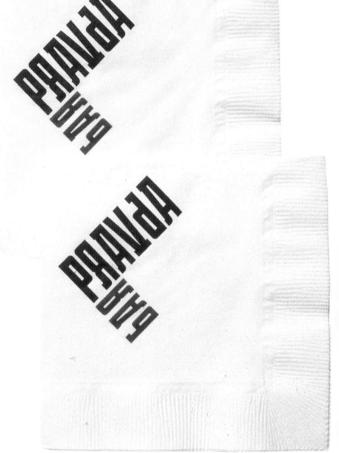

DESIGN Matteo Bologna for Matteo Bologna Design NY

PROJECT Pravda corporate identity

CLIENT Pravda

 ${\tt T} \circ \circ {\tt L} \, \$$ Fontographer, FreeHand on Macintosh

^{F ○ N T} Pravda Family (custom made)

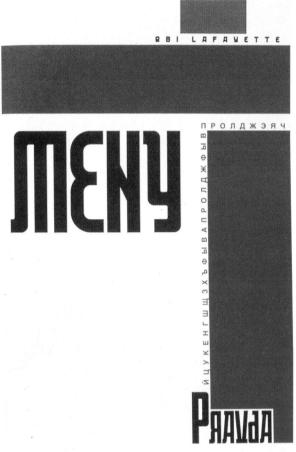

"ЧТО У ТРЕЗВОГО НА УМЕ, ТО У ПЬЯНОГО НА ЯЗЫКЕ"

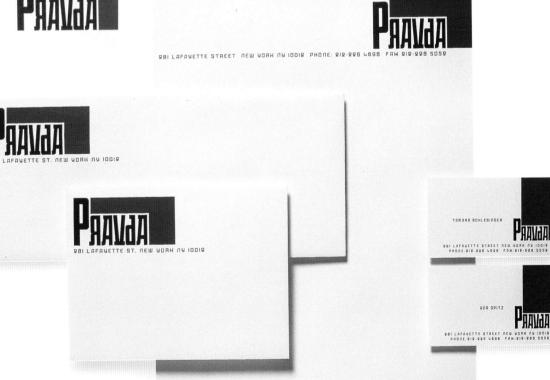

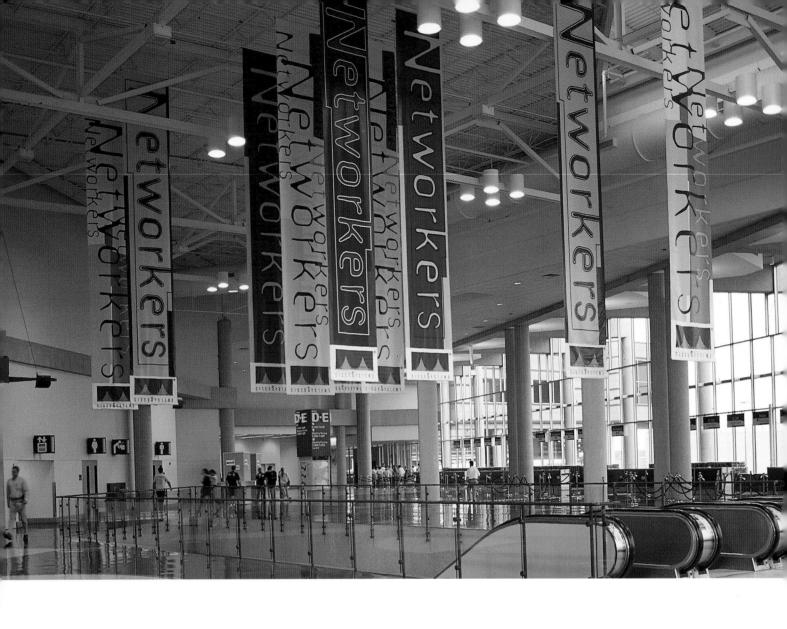

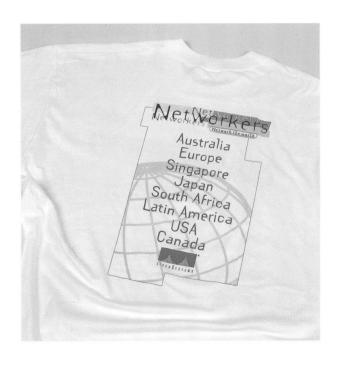

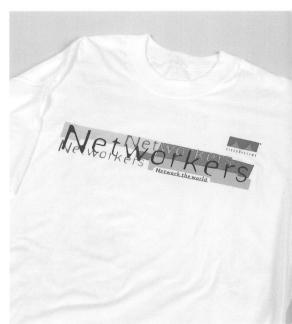

DESIGN Mark Drury for International Events

PROJECT Networkers 1996

CLIENT Cisco Systems, Inc.

TOOL\$ Adobe Illustrator on Macintosh

FONT Template Gothic

The font was **outlined and manipulated** in Illustrator. A rough body or inner weight ${\bf was}\ {\bf drawn}$ with the Wacom tablet, giving the logo several layers.

Australia Europe Singapore Japan South Africa Latin America USA Canada

Network the world

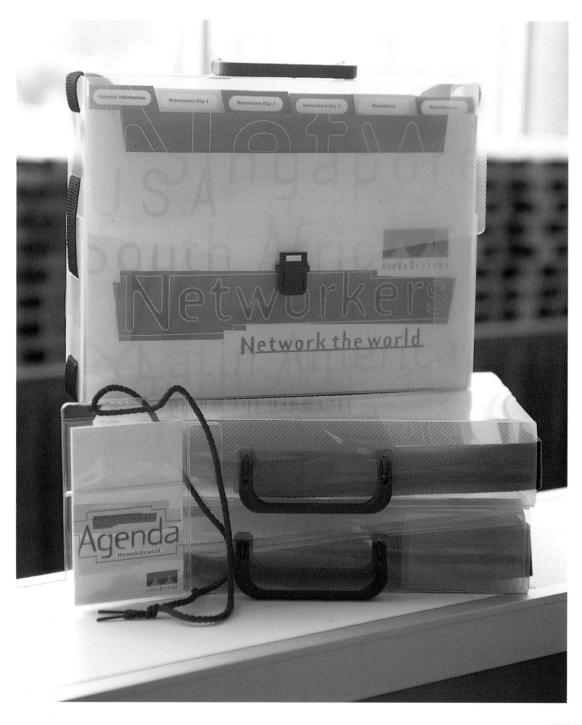

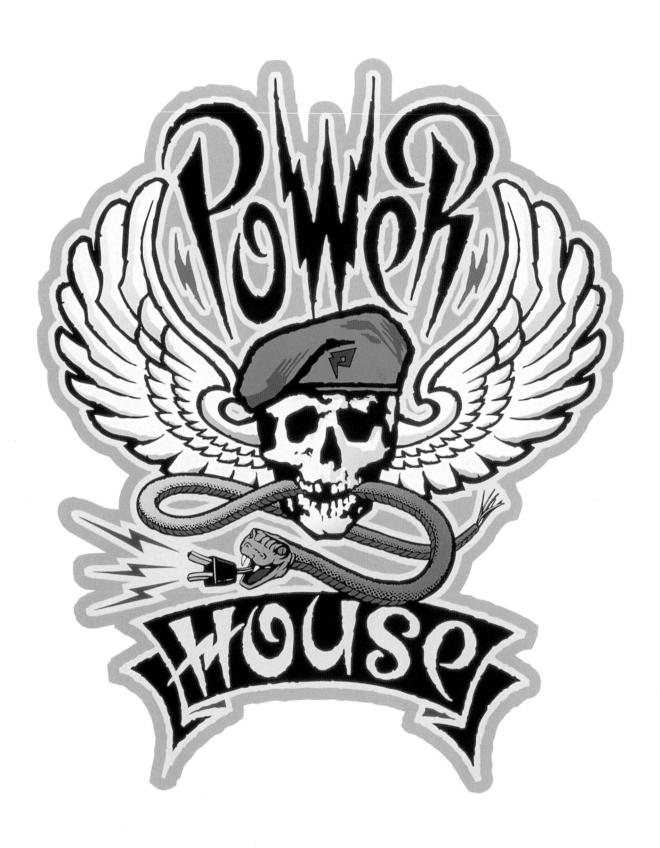

DESIGN Tony Klassen for Segura, Inc.

PROJECT B-BOX

CLIENT TVT Records

 $au\circ\iota$ Ray Dream Designer, Adobe Photoshop on Macintosh

FONT Linoscript

This is a TVT record collection called **B-Box**.

DESIGN Mike Salisbury for Mike Salisbury Communications, Inc.

¢ т Power House

CLIENT Stat House/Power House

TOOL\$ Adobe Illustrator

FONT Sketch Rough

This piece was hand **illustrated** in Adobe Illustrator. The illustrator was given a

rough sketch specifying jagged, $tattoo-style\ type\ treatment.$

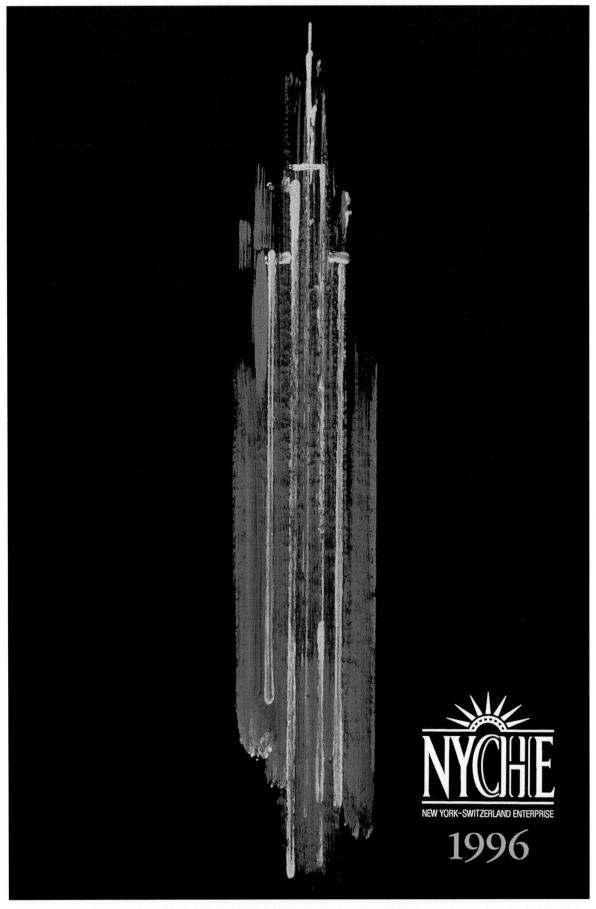

DESIGN Hans Flink, Stephen Hooper, and Mark Krukonis for Hans Flink Design Inc.

PROJECT NYCHE corporate identity

CLIENT NYCHE Inc.

 $^{\text{TOOL\$}}$ Adobe Illustrator on Macintosh

FONT Arrow

This corporate logo for NYCHE represents an international agency that promotes quality business relationships between New York and Switzerland. A modified arrow font highlights the "CH" portion of the logo ${\bf symbolizing}$ ${\bf Switzerland}$ ("Confederation Helvetia"). New York is represented by the initial letters and a stylized version of the crown of liberty.

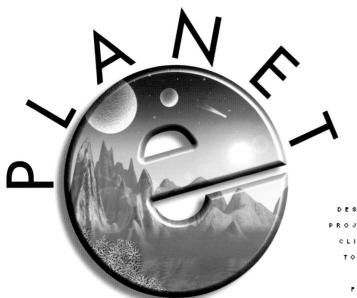

DESIGN Alan D. Giana for Giana Illustration and Design

PROJECT Planet E

CLIENT Ollivieri Communications

TOOLS Macromedia FreeHand, Adobe Photoshop, KPT Bryce, Kai's Power Tools, Fractal Design Painter, Alien Skin Black Box Filters

 ${f F}$ ${f O}$ ${f N}$ ${f T}$ Futura Extra Bold, Futura

The type was created in FreeHand, and then the "e" and "planet" type were exported individually. The designer loaded and

painted each isolated section, created the mountain scene, and then placed them into the "e" for the final design.

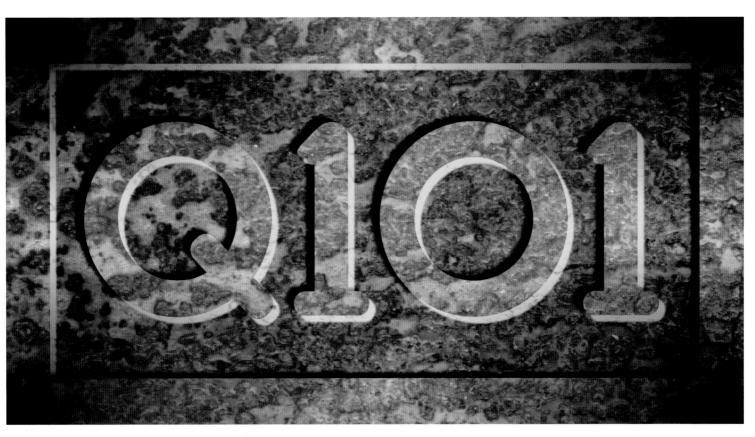

DESIGN Tony Klassen for Segura, Inc.

PROJECT Q101 logo

CLIENT Q101-Chicago radio station

TOOLS Adobe Photoshop on Macintosh

This is an alteration of the original logo.

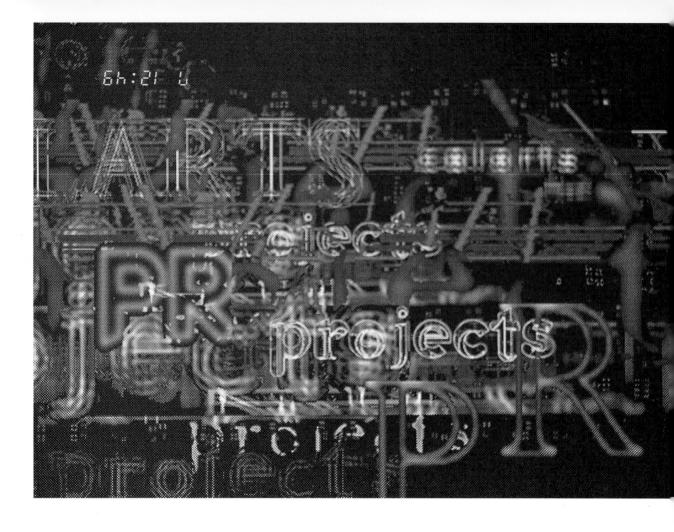

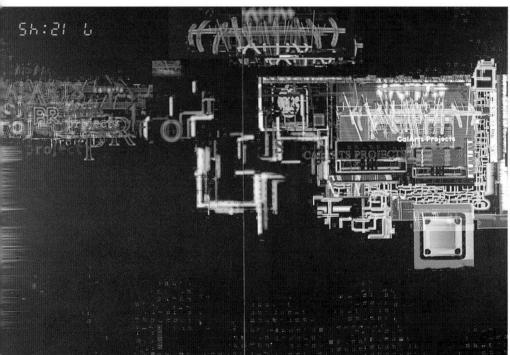

DESIGN Deborah Littlejohn and Shawn McKinney

PROJECT Fast Forward catalog spread

сьівнт California Institute of the Arts

TOOLS Adobe Photoshop

rомтя Perpetua, Vag Rounded, Keedy Sans

This catalog, designed by CalArts graduate students,

presented a series of lectures and workshops with guest designers that explored the potential of the computer in design.

It uses every known Photoshop filter available in 1993 multiplied by 1,000 times.

 $^{
m DESIGN}$ Mary Evelyn McGough and Mike Salisbury for Mike Salisbury Communications, Inc. ст *Rage* brochure and box press kit Rage magazine TOOLS Adobe Illustrator, QuarkXPress on Macintosh FONTS Platelet, Compacta, Orator

This is **a press kit to announce** a new men's magazine targeted at younger readers. Type was overlapped, stretched, and shadowed to give α dense, busy look.

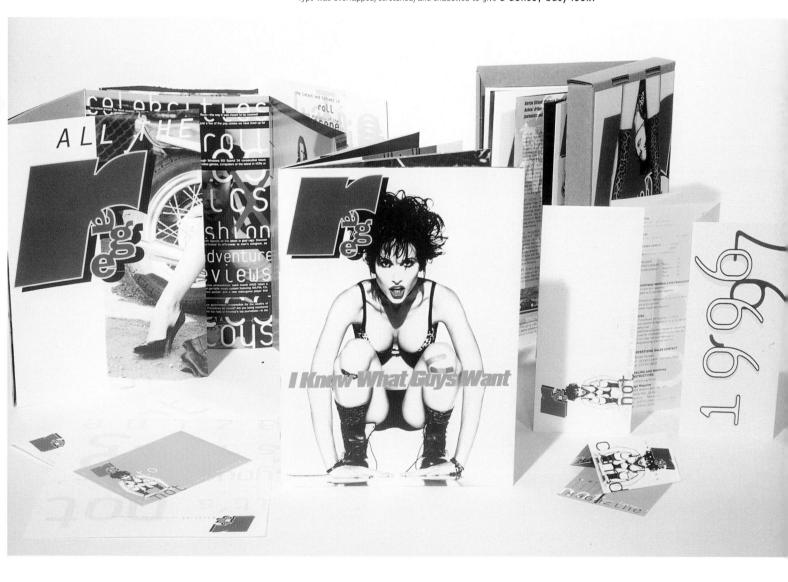

Jose A. Serrano for Mires Design, Inc.

ст Total Racquetball 1993

CLIENT Ektelon

TOOLS Adobe Illustrator, Adobe Photoshop on Macintosh

Total Racquetball is an annual publication that features the client's entire line of products, articles, tips on nutrition and on how to improve one's game, interviews with pros, and so on.

The type was selected because it conveyed a **sportslike attitude**.

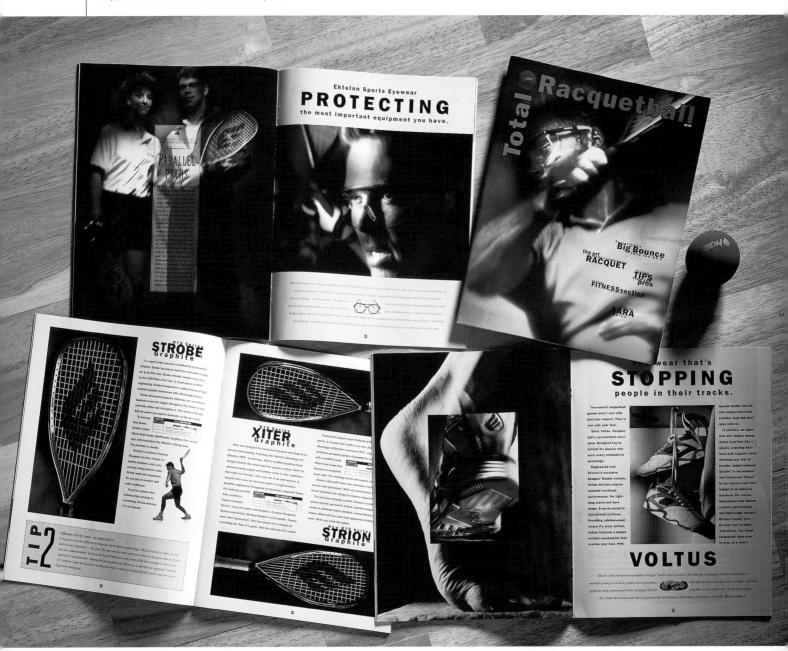

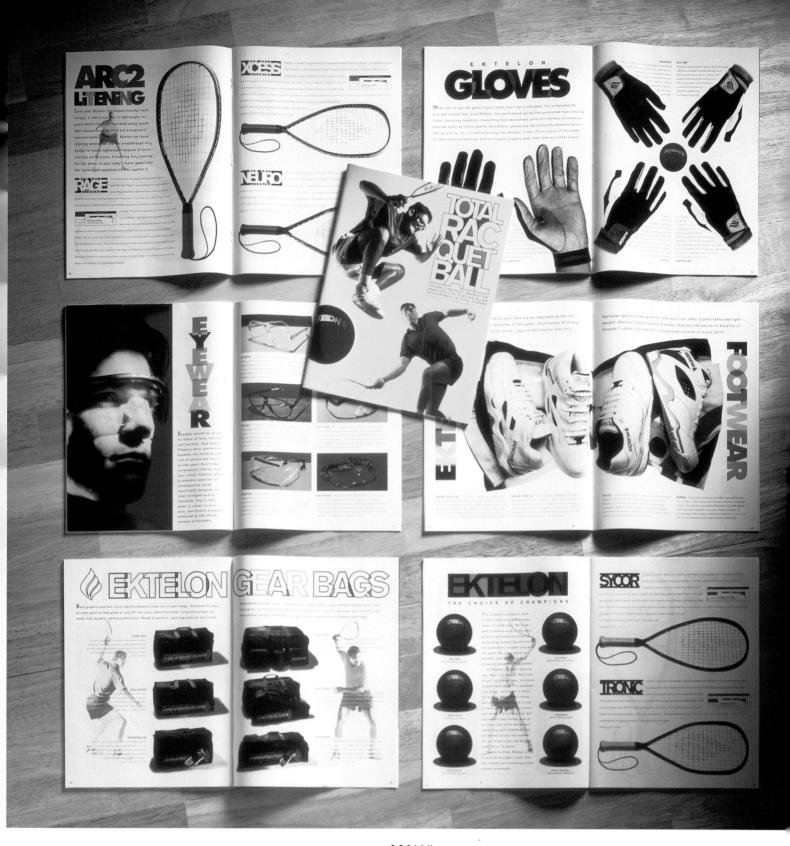

 ${\tt D.E.S.I.G.N.}$ Jose A. Serrano for Mires Design, Inc.

PROJECT Total Racquetball 1994

CLIENT Ektelon

TOOLS Adobe Illustrator, Adobe Photoshop on Macintosh

Total Racquetball is an annual publication that features the client's entire line of products, articles, tips on nutrition $% \left(1\right) =\left(1\right) \left(1\right) \left$ and on how to $improve\ one's\ game,$ interviews with pros, and so on. The type was selected because it conveyed a $sportslike\ \alpha ttitude.$

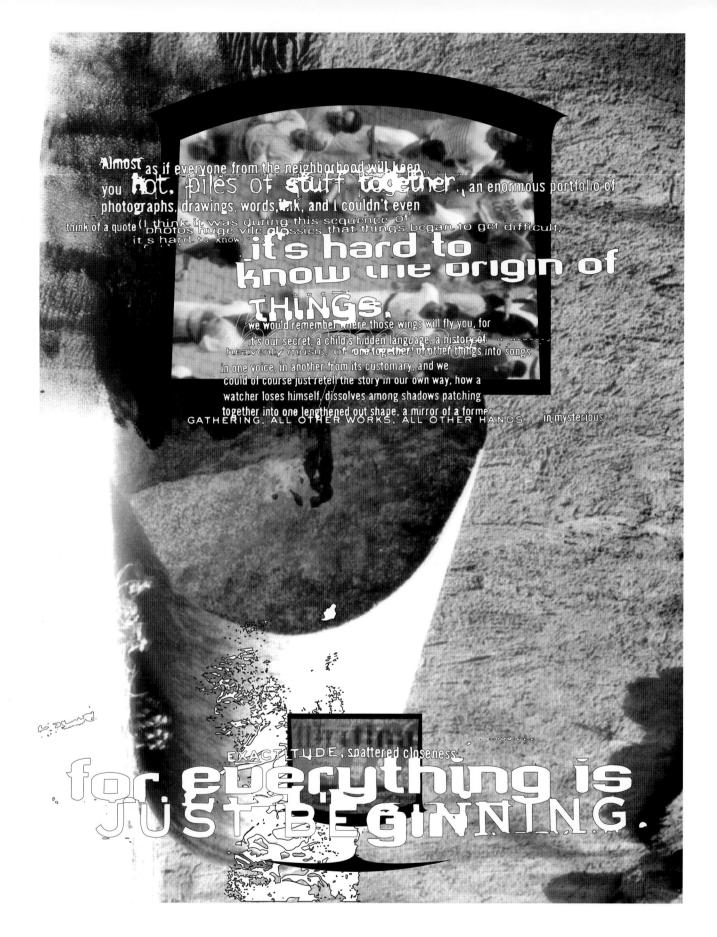

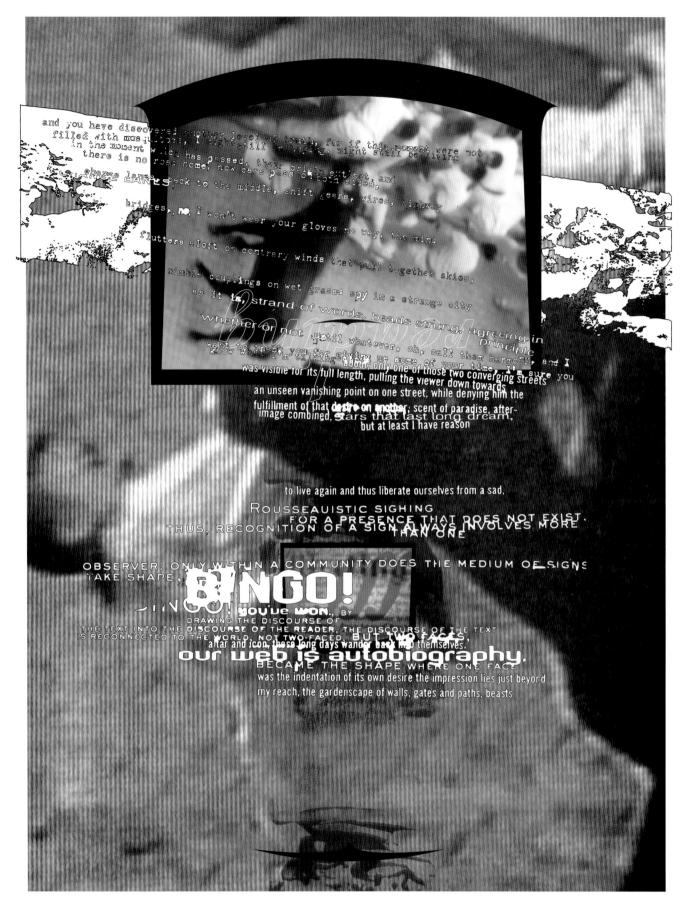

Stephen Farrell for SLIP A House Swarming! Private Arts literary/arts journal TOOLS Adobe Illustrator, Adobe Photoshop, Adobe Streamline on Macintosh Beach Savage, Evangelic, Escalido, Werkman-Round, Atsackers Gothic, Coronet, 1940 Smith Corona Typewriter Elite

"A House Swarming!" was published as a poem/foreword in

the literary/art journal Private Arts.

The design fractures both the letterforms and narrative of a text, which is composed of bits plagiarized from other texts in the journal.

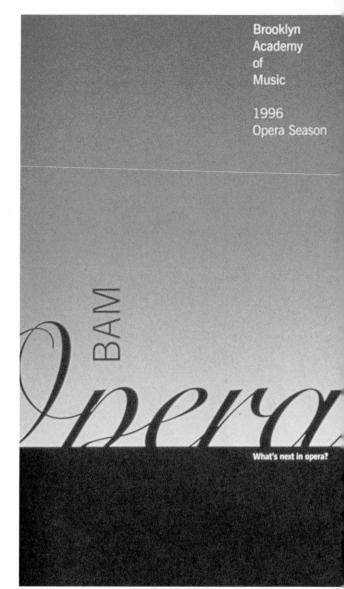

 $^{\text{D}}$ E \$ 1 G N $\,$ Michael Bierut and Emily Hayes for Pentagram Design РВОЈЕСТ Brooklyn Academy of Music opera brochure СLIENT Brooklyn Academy of Music TOOLS QuarkXPress on Macintosh FONT Snell Roundhand

The wide stripes partially **conceal the type** to suggest something coming over the horizon, α visual metaphor for the Festival's focus on emerging talent. Subsequent brochures use variations on this theme,

incorporating script or simply cutting off lower parts of letters.

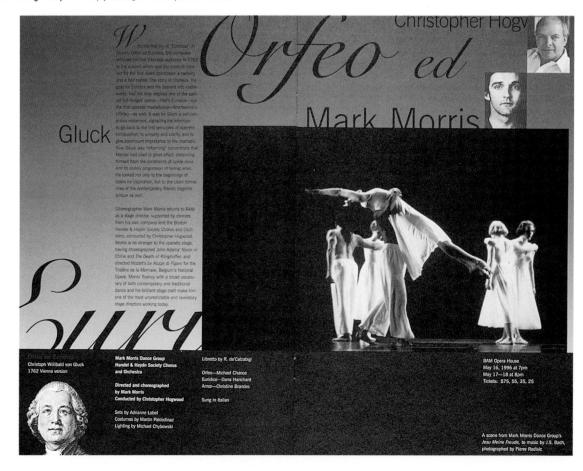

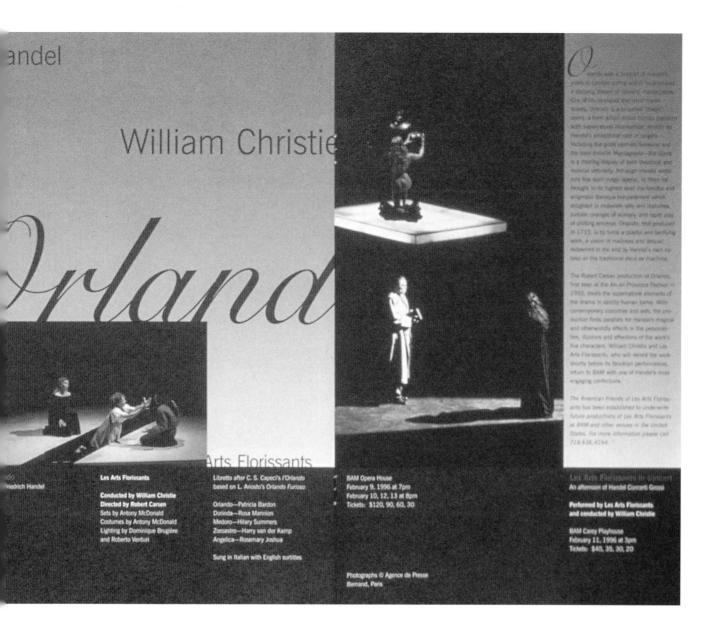

DESIGN Norman Moore for Design Art, Inc.

PROJECT RCA Jazz catalog

CLIENT RCA/BMG

TOOLS Adobe Photoshop, QuarkXPress on Macintosh

FONT Degenerate

This is a jαzz catalog cover.

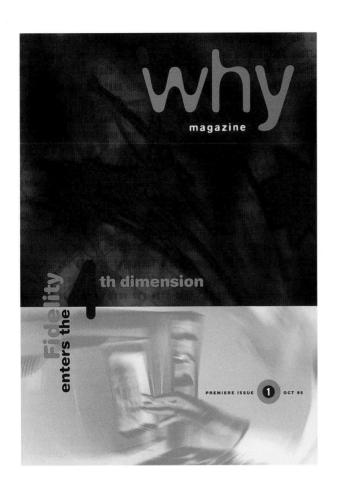

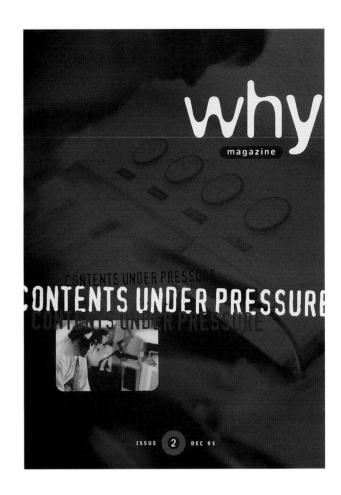

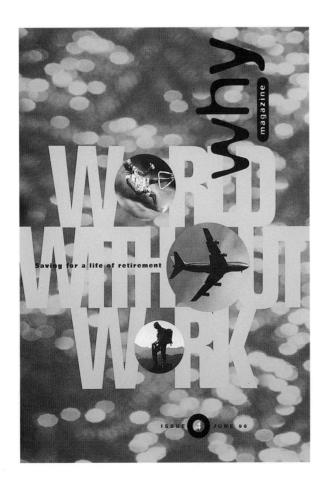

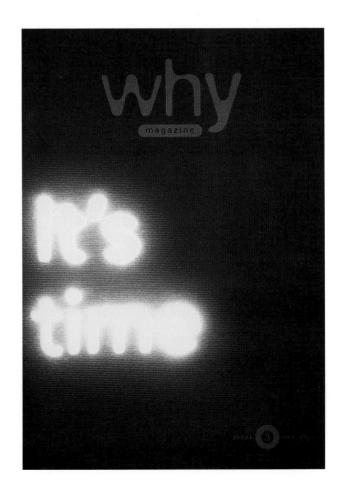

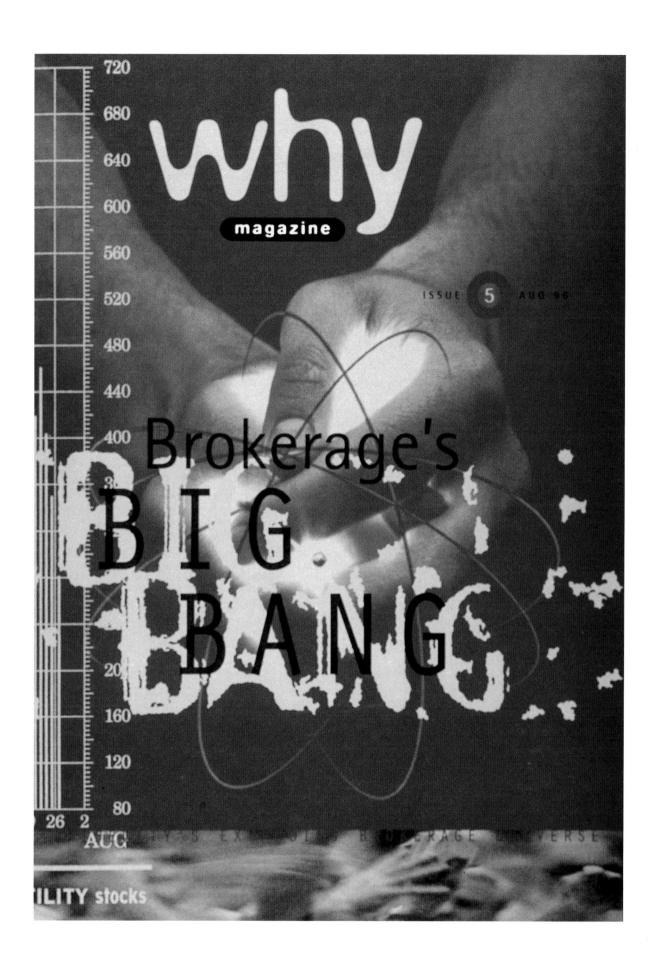

DESIGN Clifford Stoltze and Dina Radeka for Stoltze Design PROJECT Why Magazine, issues 1-5 CLIENT Fidelity Investments

 $\textbf{\textit{Why Magazine}} \text{ is an internal publication of Fidelity Retail Communications.}$ It provides context for **key Fidelity strategies and businesses.**

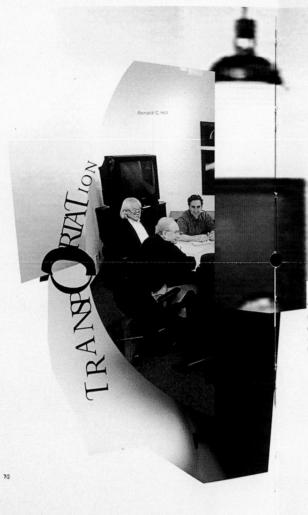

RONALD C. HILL

"The transportation design profession is undergoing tremendous change. At Art Center we look for those students who question the status quo, the ones who are convinced that they can design a better, more attractive, and more efficient vehicle. Our students come to us with that they can design a better, more attractive, and more urge, but it's our task to provide the methodologies and tools to allow them to achieve their full potential. Transportation design is particularly challenging because of its enormous impact on our society. Future designers who respond sensitively to these challenges will provide inestimable benefit to the environment."

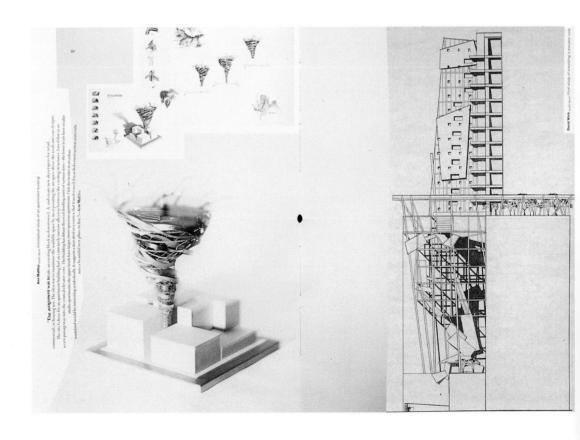

The perforation bisects the headlines identifying the areas of study at Art Center, creating hybrid words and opening our minds to the interdisciplinary and multidisciplinary environment at the college. The typography momentarily forgets its classical roots and its autonomy. Certain elements of the typography were randomly "distressed" so that its fluidity is revealed as it is affected by surrounding elements.

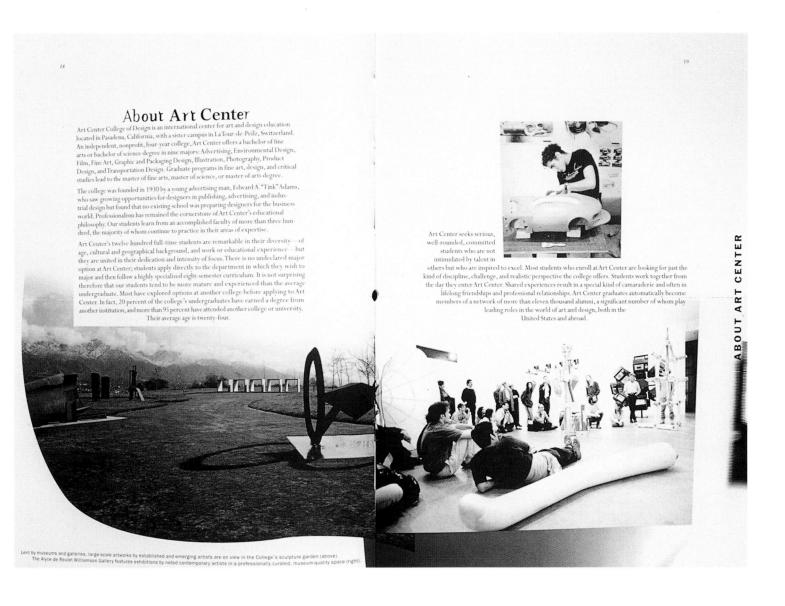

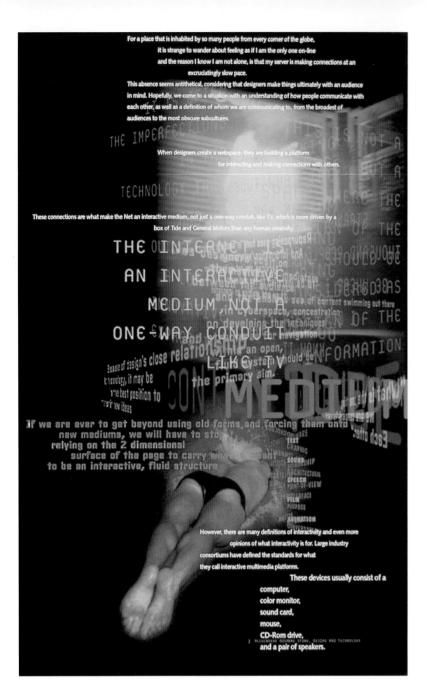

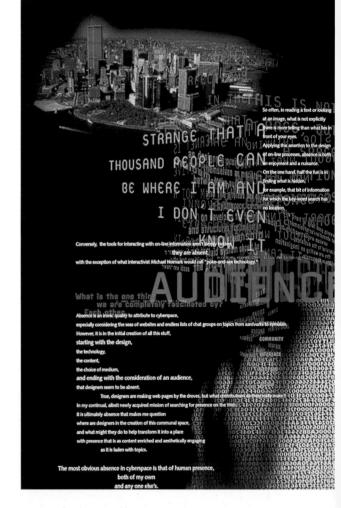

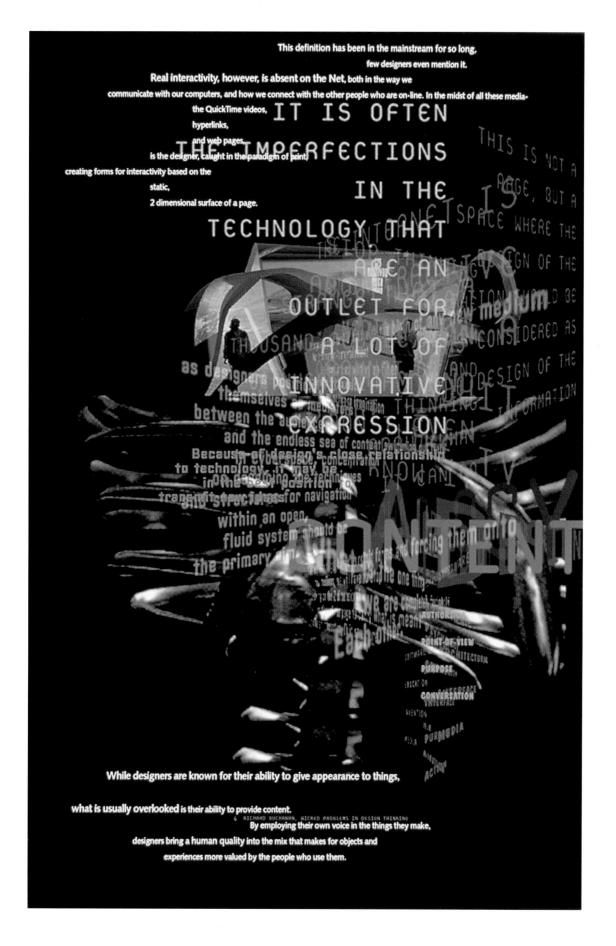

Deborah Littlejohn Article on webspace design Photoshop on Macintosh FONTS Platelet, Hobo, Clicker

These panels demonstrate **3-dimensional text** as applied to the Internet. Photoshop was used to mimic a proposed inhabitable space in which the audience can communicate in a 3-dimensional world.

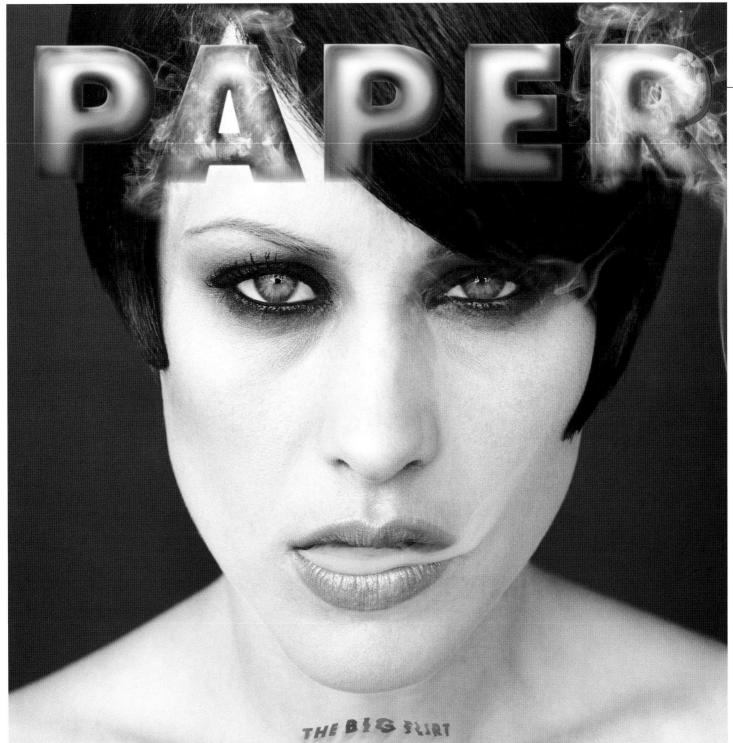

Patricia Arquette

Wooing John Woo . Spanish Fly Pedro Almodóvar Spike Lee's Phone-Sex Girl MUSIC: Lovin' DJ Krush, Maxwell, The Supreme Dicks Malcolm Turk and Bridget De Socio for Malcolm Turk Studios Paper magazine cover, March 1996 Paper magazine Adobe Illustrator, Adobe Photoshop on Macintosh Futura Extra Bold

> The logo was created with channel offsets, embossing, lighting effects, and layer masks. The smoke was photographed against a black background and scanned before being manipulated to create a cleaner image.

Malcolm Turk and Bridget De Socio for Malcolm Turk Studios Paper magazine cover, June 1996 Paper magazine ◦៤\$ Adobe Illustrator, Adobe Photoshop on Macintosh FONT Futura Extra Bold - Water droplets were photographed on a blue screen

to allow for ease in composition. The logo's cutout appearance was accomplished through shadowing and layering.

 $\label{eq:continuous} \textbf{An embossed stroke} \text{ was then added to give the logo more definition.}$

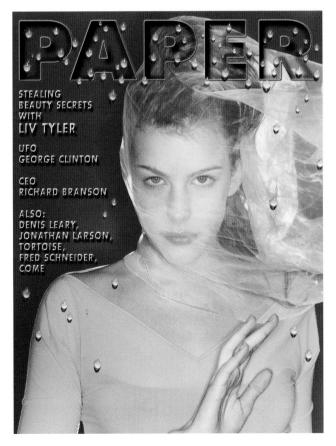

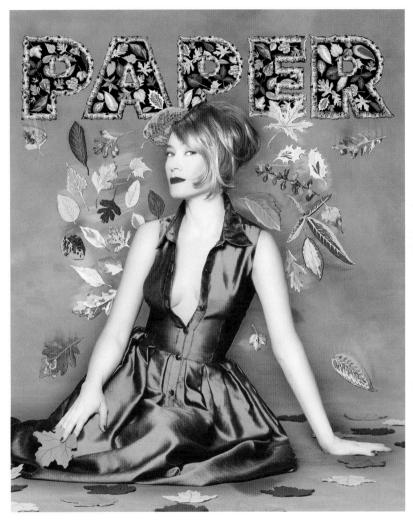

Malcolm Turk and Bridget De Socio for Malcolm Turk Studios Paper magazine cover, November 1995 Paper magazine Adobe Illustrator, Adobe Photoshop on Macintosh Futura Extra Bold Both the leaves and the type border were scanned and then manipulated.

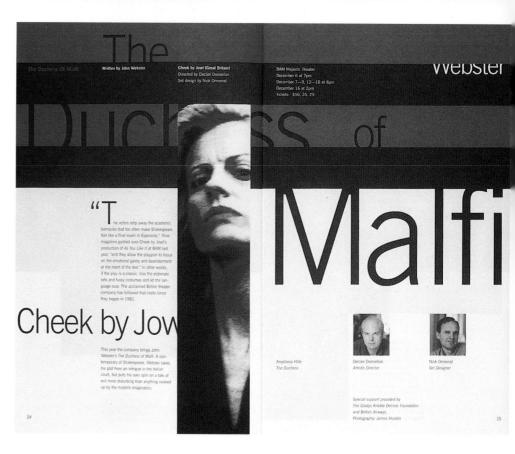

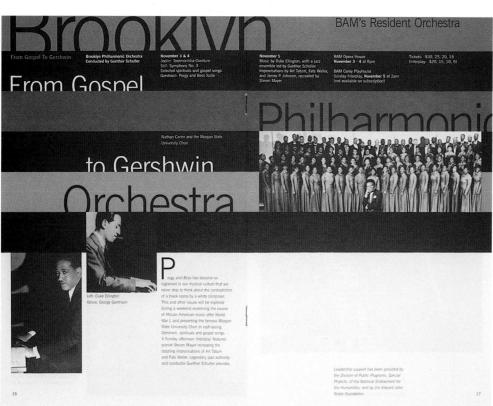

DESIGN James K. Brown for Pentagram Design Brooklyn Academy of Music Next Wave Festival 1995 brochure Brooklyn Academy of Music TOOL\$ QuarkXPress FONT News Gothic

The layout for BAM's Next Wave Festival program was organized around a motif of wide stripes.

Type is partially concealed by the stripes to suggest something

"coming over the horizon," a visual metaphor for the festival's focus on emerging talent. Subsequent brochures use different variations,

incorporating script or simply cutting off lower parts of letters.

Brooklyn Academy of Music

Mave

Festival is sponsored by Philip Morris Companies Inc.

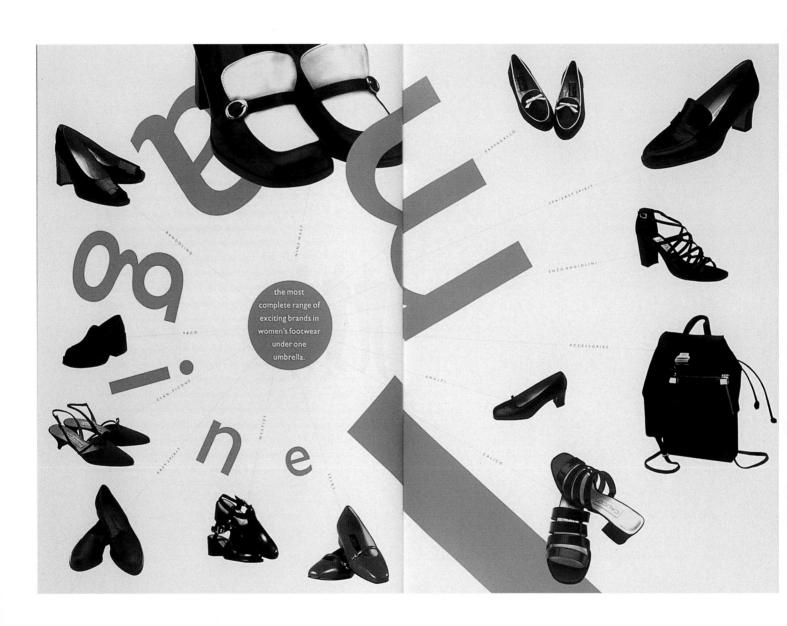

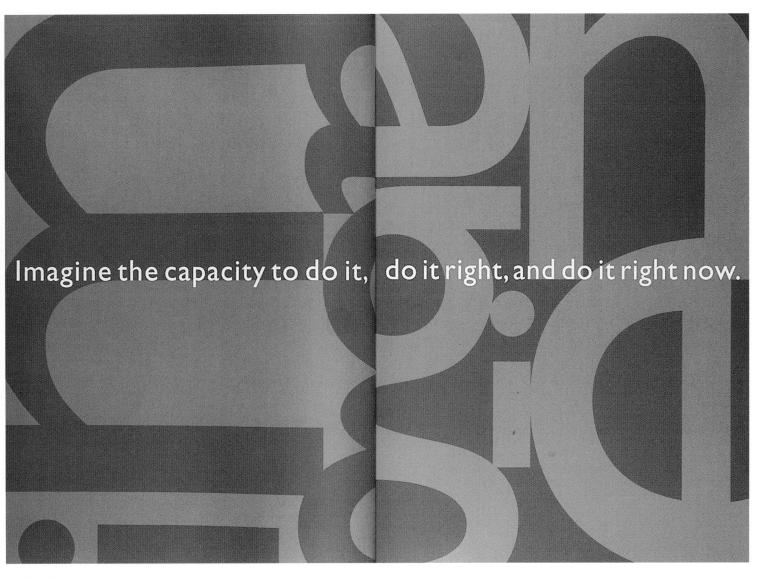

James K. Brown for Pentagram Design

Nine West 1995 annual report

Nine West Group, Inc.

TOOL\$ Adobe Illustrator, QuarkXPress on Macintosh

FONTS Gill Sans

Nine West Group is a leading designer, developer,

and marketer of women's fashion footwear. The cover presents an image that is focused toward the future.

Bold and imaginative typographic treatments emphasize the company's

success in understanding and meeting the needs of its customers.

Bulk Rate U.S. Postage Paid Los Angeles, CA

Permit no I23

Stathouse
8126 Reverly Boulevard Los Angeles, CA 90048 PO. Box 48527 Tel. 213-653.8200 Fax 213-653.0168

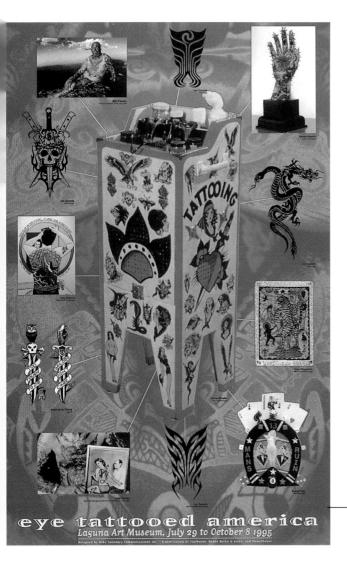

DESIGN Mike Salisbury, Sander van Baalen, and Sander Egging for Mike Salisbury Communications, Inc. ROJECT Housestyle newsletter Stat House/Power House $au\circ \circ \iota \circ$ QuarkXPress, Adobe Illustrator, Adobe Photoshop on Macintosh FONTS Matrix, Wilhelm Klingspor Gotisch

This is the design for **the premiere issue** of a quarterly newsletter published

by Stat House (a digital and conventional service bureau) featuring Los Angeles design and art events.

The designers chose the type to reflect the **theme of this issue: tattoo art.**

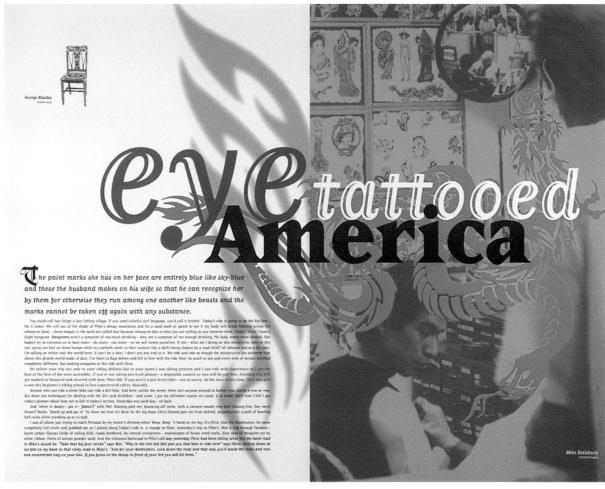

DESIGN Carlos Segura for Segura, Inc. PROJECT 1996 XXX Snowboards catalog cover TOOL\$ Adobe Illustrator, Adobe Photoshop, QuarkXPress FONT Proton

— This year, the catalog took the shape of a trip diary, planner, calendar, snowboard tips and ethical guidelines, travel information, and resort, car, and airline 800 numbers.

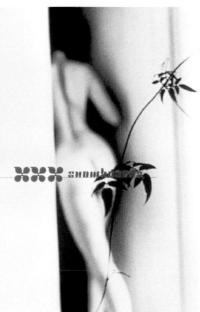

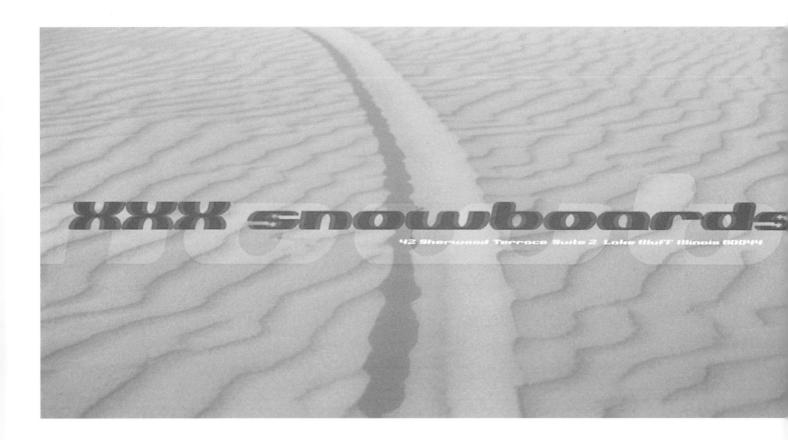

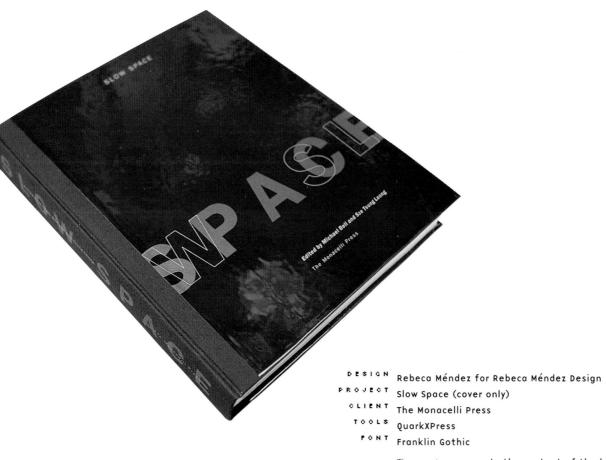

 The cover type reasserts the content of the book, which relates theories of time, the city, and "authentic architectural experience."

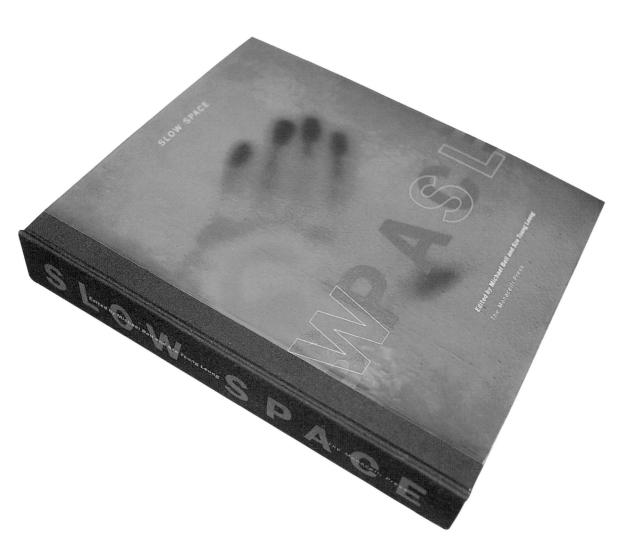

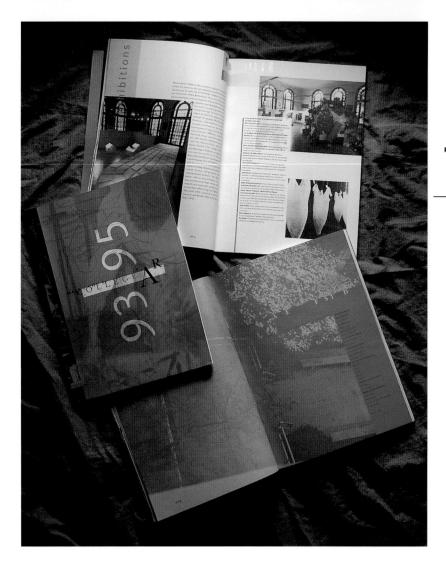

DESIGN Clifford Stoltze, Kyong Choe, Rebecca Fagan, and Peter Farrell for Stoltze Design JECT Massachusetts College of Art 93-95 catalog

IENT Massachusetts College of Art FONTS Meta, New Baskerville, Trixie

Baskerville and Meta are incorporated to suggest the old and the new, which contrast with Trixie used for student quotes.

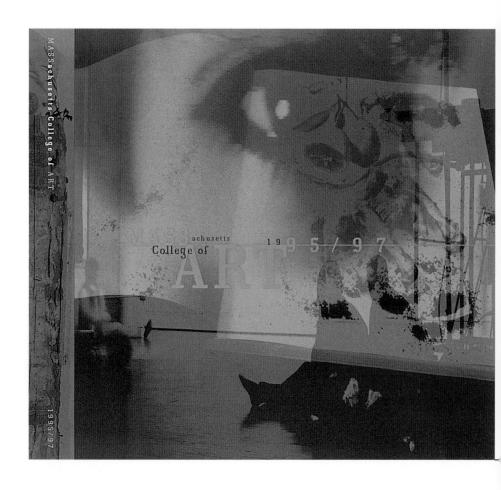

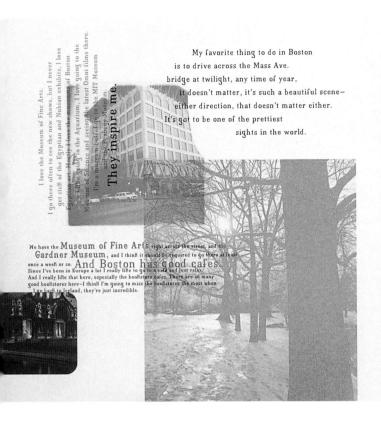

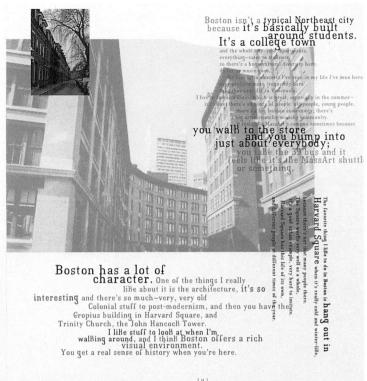

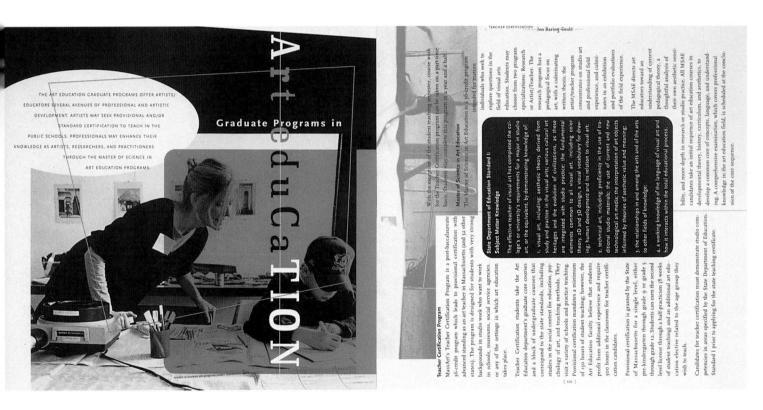

DESIGN Clifford Stoltze, Tracey Schroeder, Heather Kramer, Peter Farrell, and Resa Blatman for Stoltze Design Massachusetts College of Art 95-97 catalog Massachusetts College of Art

PONTS Scala Sans Serif, Scala Serif, Calvino

Scala Sans Serif and Scala Serif are used with Calvino, adding a more

Z A T I O R В \mathcal{O} \times R A In 1946, helped he RE *50*TH the Wounds of 田 Warin Europe C A R

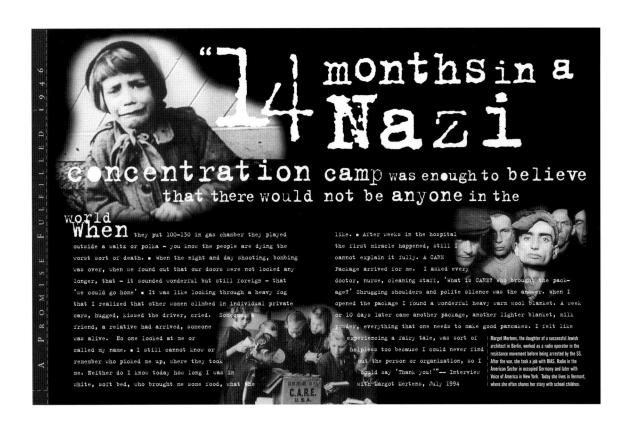

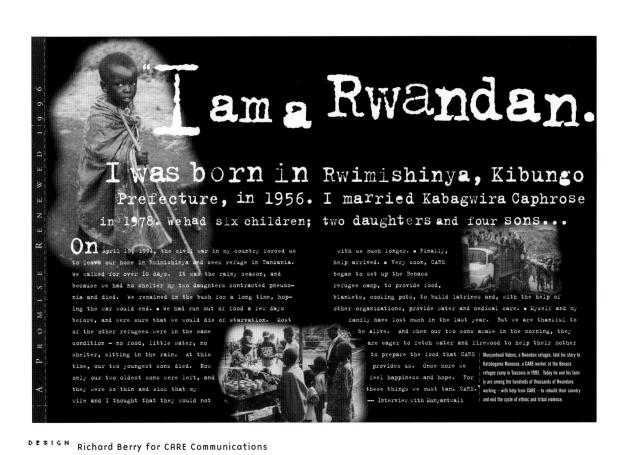

The original photo prints were scanned in-house,

TOOL\$ Adobe Photoshop, QuarkXPress on Macintosh

PROJECT CARE's 50th Anniversary Journal

manipulated in Photoshop, brought into QuarkXPress, and output directly to film. On the "Concentration Camp" spread and the "Rwanda" spread, the type was set in a small point size and enlarged several generations on a photocopier. The final copies were scanned into Photoshop, where some additional tweaking was done.

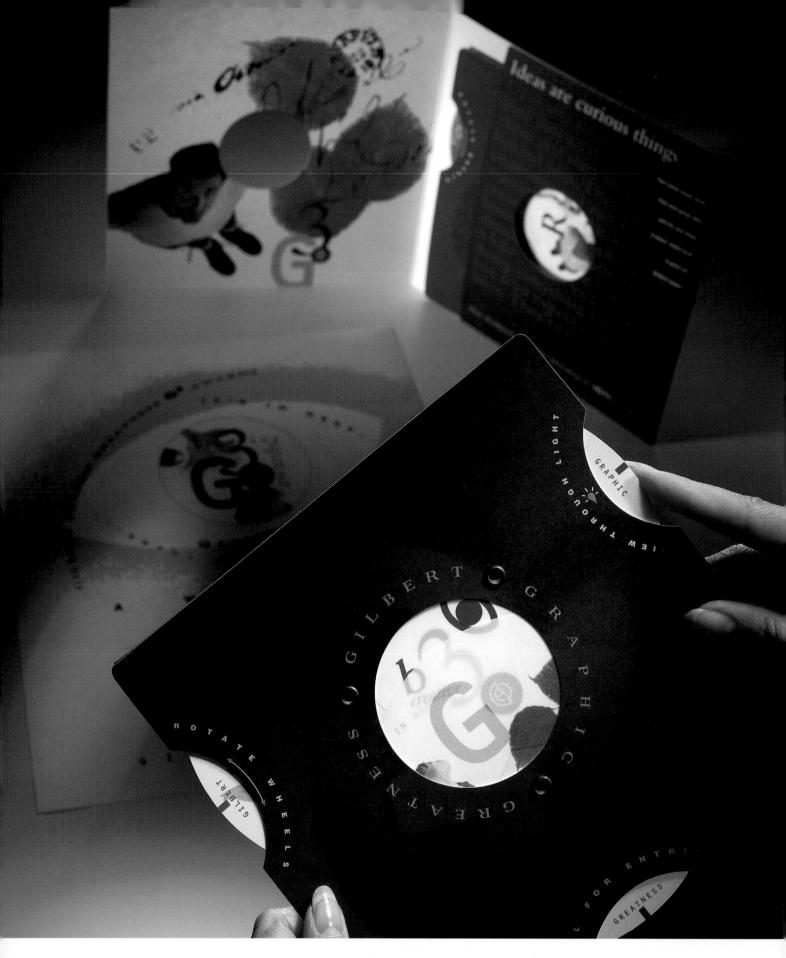

 ${\tt D\,E\,S\,I\,G\,N}$ Michelle Aranda and Ron Miriello for Miriello Grafico, Inc.

PROJECT Gilbert G3 Awards

CLIENT Gilbert Paper Company

TOOL\$ Adobe Illustrator, Adobe Photoshop on Macintosh

FONT\$ Bembo, Helvetica, ITC Kabel

To reinvigorate the awards program, a call-for-entries brochure using a turning-wheel design of type and photo images allows for endless combinations.

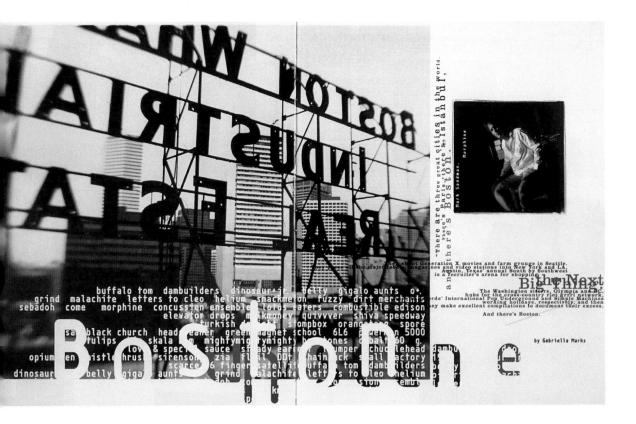

Clifford Stoltze and Peter Farrell for Stoltze Design Boston Music Scene Feature in Raygun, issue 20 Raygun Magazine

Isonorm, Clarendon

The challenge was to use fonts that $h\alpha d$ never been used in $\it Raygun$ before. The $\it designers$ chose Isonorm and Clarendon to contrast old and new.

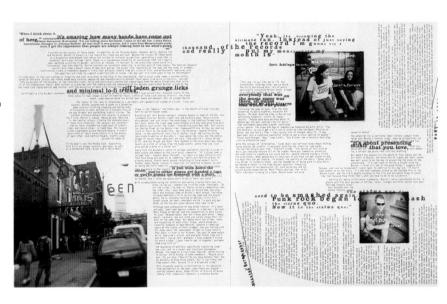

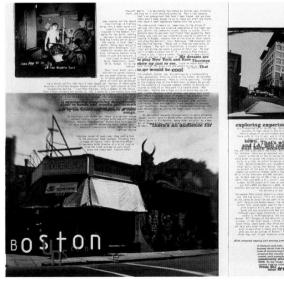

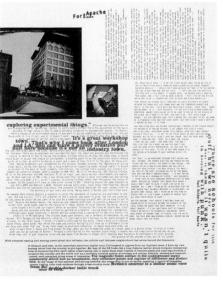

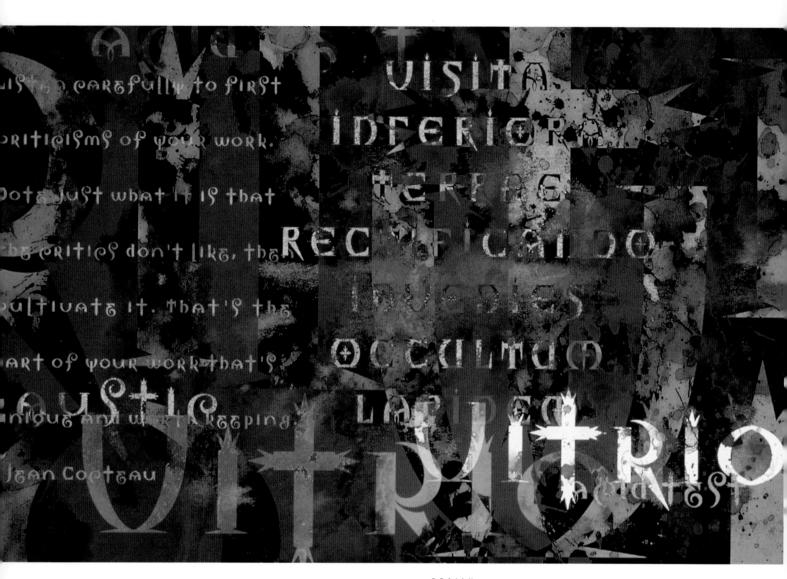

Margo Chase for Margo Chase Design

rools Fontographer

FONT Vitriol

The **inspiration** for this font was

Medieval manuscripts and Gothic versal caps.

The lowercase works as a complete **font** without uppercase. The designer intended the **capitals** for ornamental letters only.

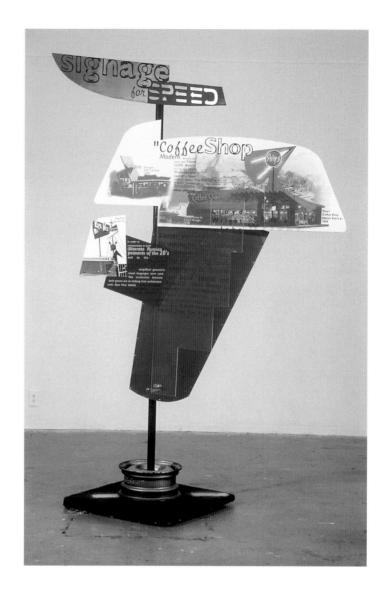

DESIGN Todd Childers for Todd Childers Graphic Design PROJECT California Arts MFA Thesis

TOOL\$ Illustrator and Photoshop on Macintosh

This is a portion of a **thesis** concerning the evolution of the roadside environment in America.

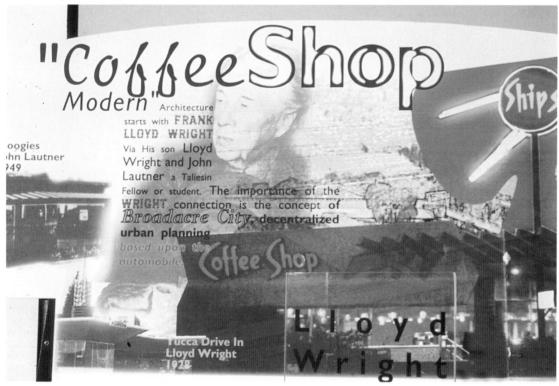

DESIGN Sander van Baalen and Andre Hanegraaf
CLIENT Utrecht School of the Arts (H.K.U.)

TOOLS FONT Studio
Logic

These typeface forms are **based on an I.C. chip** taken from a typesetter made in 1971. The font is **an ode to the new typographic tools.** Each design package includes a disk, a real I.C. chip, and three type example cards: plain, oblique, and oblique extended.

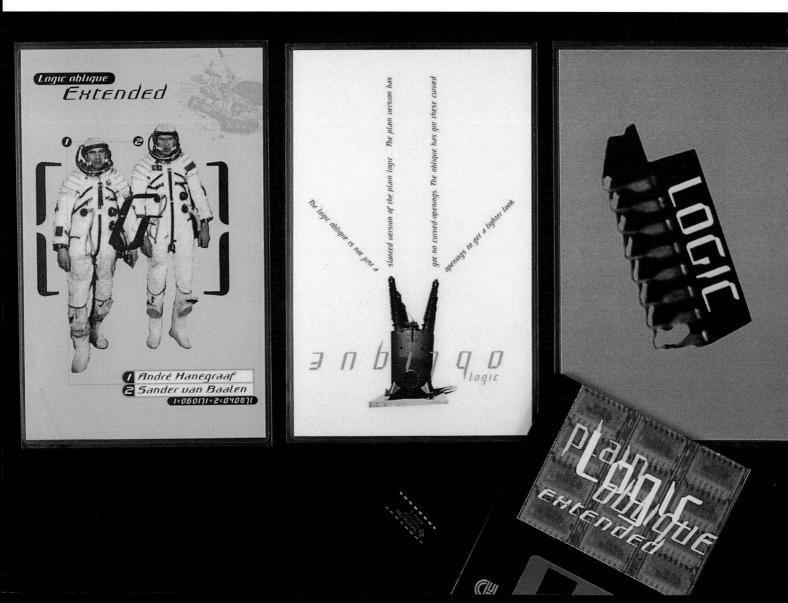

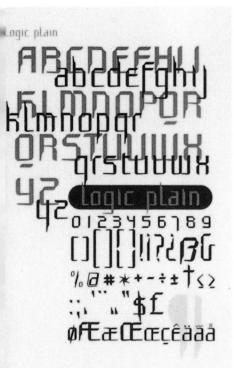

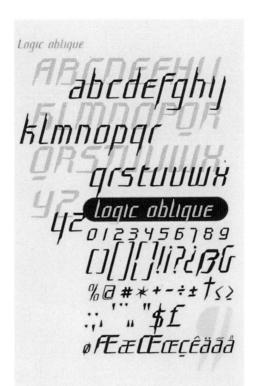

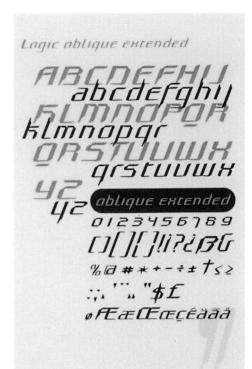

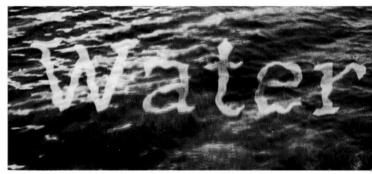

Jure Stojan for Stojan Type Specimen Adobe Photoshop on PC Pekel Regular

To illustrate creative usage of a new typeface, the designers used Photoshop's layering feature. After altering the shapes of the letters, the designers used opacitysliders to apply transparence then diffused the image.

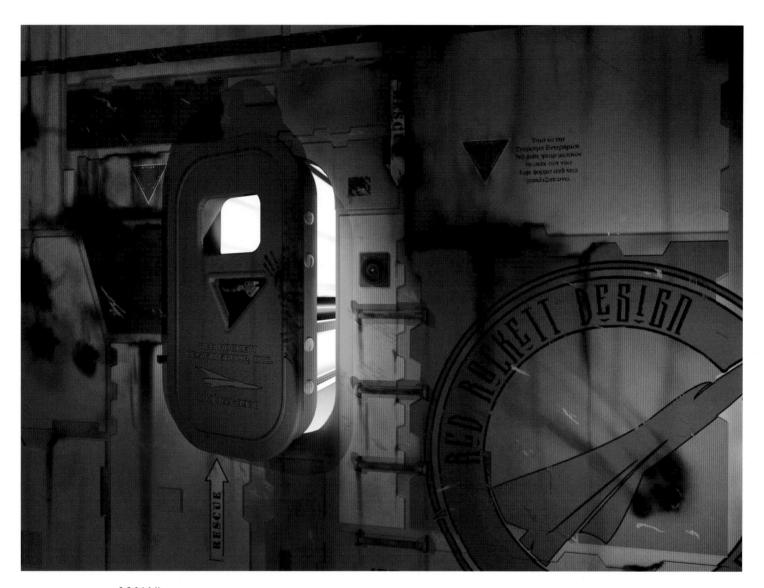

Adam Murguia and Ned Rickett for Red Rockett Design

Promotional pieces

Adobe Illustrator, Adobe Photoshop, Strato Studio Pro

NTS Eurostile Extended, Stencil, Kells, Halfway House, Symbol

The design was created with Illustrator and Photoshop, and Strata Studio Pro was used to $\alpha dd \ dimension.$

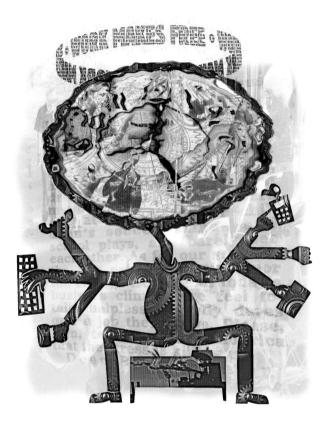

Kelly Brother for Kelly Brother Illustration

Work Makes Free

Adobe Illustrator, Adobe Photoshop on Macintosh

FONTS Newspaper Clippings, Block Condensed

This piece is a visual commentary on corporate downsizing and overworked laborers.

Some of the images were taken from a CD-ROM,

while others were **scanned**. The illustration was then opened in Photoshop, where textures, colors, and layers were added.

The head was created by scanning the face of a clock.

DESIGN Kelly Brother for Kelly Brother Illustration ¢ ▼ Wrestlers

* Adobe Illustrator, Adobe Photoshop on Macintosh

FONTS Newspaper Clippings, Block Condensed

This piece is a visual commentary on $\ensuremath{\text{hostile}}$ land $\ensuremath{\text{wars.}}$

A hand-drawn map and headlines from various newspapers were scanned to create the textures and layers of meaning. The airbrush tool, set to "dissolve," was used extensively to create texture.

The "alien" creature signifies the $\alpha lien$ $\alpha spects$ of mankind.

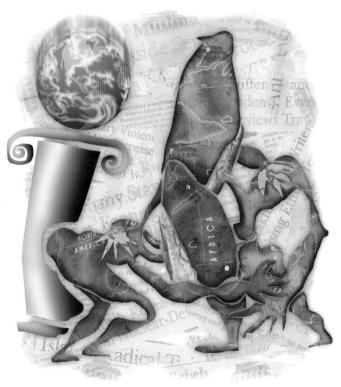

DESIGN Rich Godfrey for FUSE, Inc.

ROJECT DiVitale advertisement

CLIENT DiVitale Photography

TOOLS Adobe Illustrator, Adobe Photoshop, Fontographer
FONT Letter Gothic

This font was designed to **create a visual** identity for a photographer.

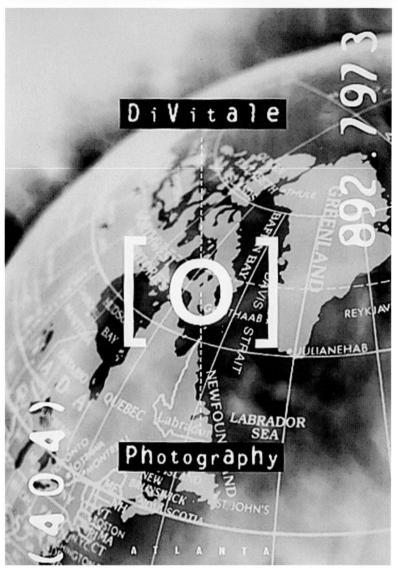

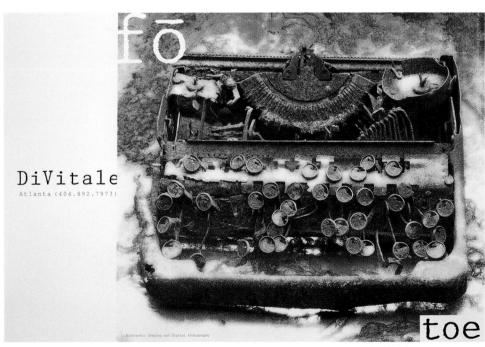

DESIGN Rich Godfrey for FUSE, Inc.

₽ŖĠĴĒĊŢ DiVitale advertisement

CLIENT DiVitale Photography

TOOL\$ Adobe Illustrator, Adobe Photoshop, Fontographer on Macintosh

FONT Scan from a manual typewriter

The typewriter font was chosen to be consistent with the

image of an old typewriter.

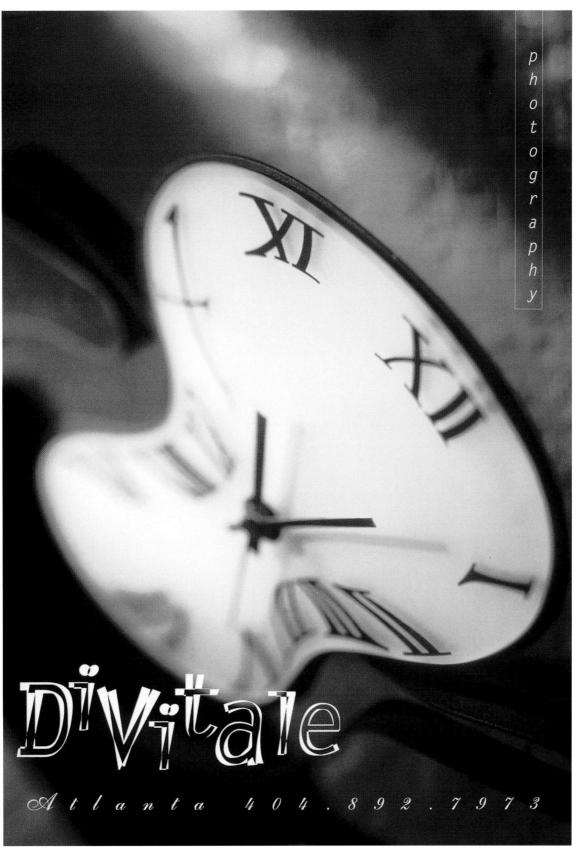

DESIGN Rich Godfrey for FUSE, Inc. PROJECT Photo Source Book advertisement CLIENT Divitale Photography $au\circ L$ \$ Illustrator and Photoshop on Macintosh

> This font was **created** by masking a roman **letter** into an italic letter of the same **font**.

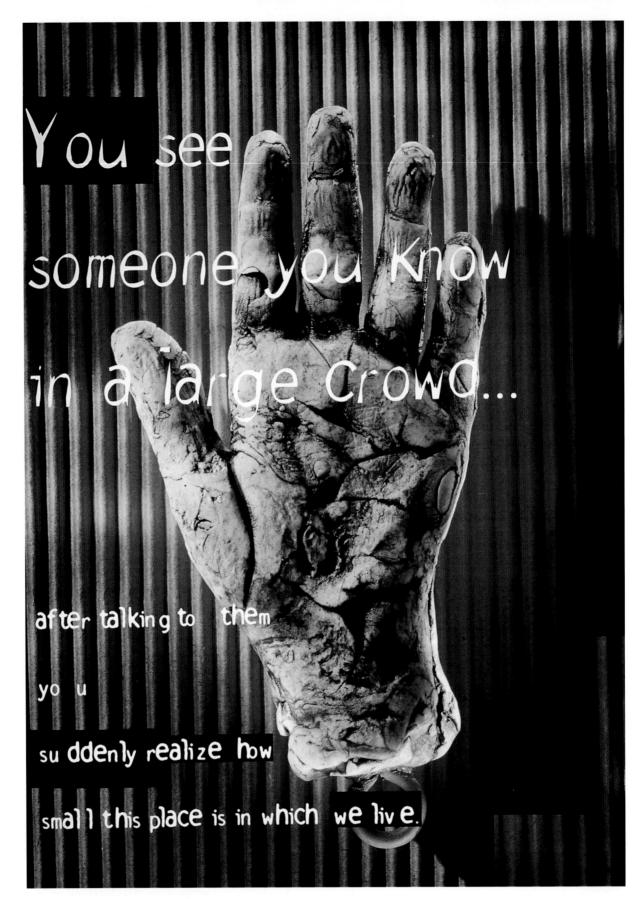

DESIGN Rich Godfrey for FUSE, Inc.

PROJE¢↑ DiVitale advertisement—black book promotion

CLIENT DiVitale Photography

^{T ◇ ◇ L \$} Adobe Illustrator, Adobe Photoshop, Fontographer

FONT Letter Gothic

This is an ad done for a black book promotion in which DiVitale was the photographer. The designer wonted the type and the image to look similar so that people would connect the ad and the promo.

Deborah Littlejohn

Imagery for self-authored essay on digital media

Photoshop

OCRA, Künstler Script, Baskerville

These images were generated to accompany

an essay on digital typography meant to be ${\tt read}$, ${\tt viewed}$, and ${\tt experienced}$ on a ${\tt computer}$ screen. The fluid, animated, three-dimensional world of the computer needs dynamic,

 $three-dimensional\ typography.\ Filters,\ lights,\ gels,\ and\ \textbf{35mm film captured the text}\ printed\ on\ cellophane,$ vellum, and Mylar. The photos were further manipulated in Photoshop.

DESIGN Margo Chase for Margo Chase Design

TOOLS Fontographer

FONT Envision

Envision was designed as a ${\tt contemporary}$ version of uncial alphabets. The designer based the forms on uncial and "symbol" fonts and the proportions on Polotino.

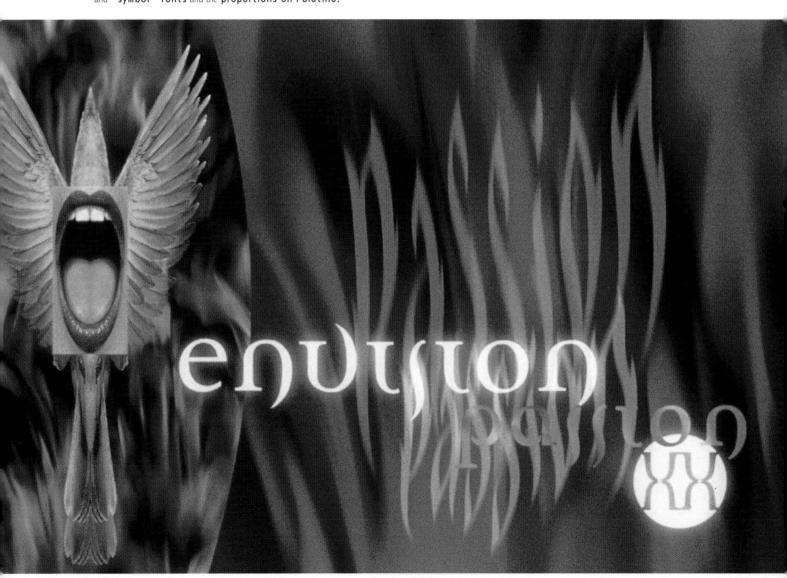

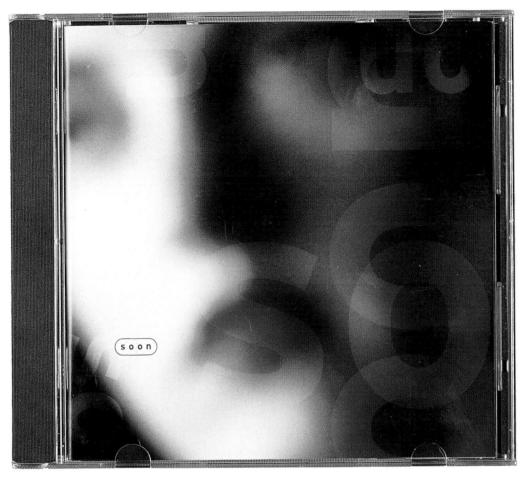

DESIGN Fritz Klaetke for Visual Dialogue

PROJECT Soon CD packaging

CLIENT CVB Studios

TOOLS Adobe Photoshop, QuarkXPress on Macintosh

Type subtly overlays an **out-of-focus photo** that conveys the **general mood** of this collection of songs.

The CD is used as a **promotion for bands and illustrators** and is sold with all proceeds going to the Aids Action Committee in Boston.

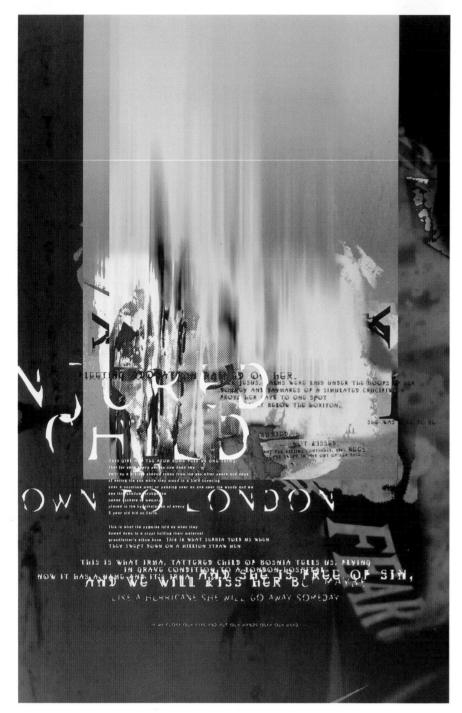

Stephen Farrell for SLIP Injured Child Flown to London TOOLS Adobe Photoshop, QuarkXPress, Adobe Illustrator, Fontographer on Macintosh FONTS Commonworld, Entropy, Stamp Gothic

An example of text illustrating the typeface in which it appears. Both **comment on brokenness:** the poem on the broken social and political structures of Europe, and the typeface on the fractured nature of communication in English.

Commonworld was developed from Garamond and Industry Sans, and Entropy is from Missive and Carmella.

Stephen Farrell for SLIP Place is Assemblage is Display Type Confetti magazine $au\circ\iota\,$ Adobe Photoshop, QuarkXPress, Adobe Illustrator, Fontographer on Macintosh FONTS Missive, Entropy, Osprey

> The three typefaces are **derivations** of one another, inspired by the designer's move to an urban environment. The montage forms, modeled from bits $% \left(1\right) =\left(1\right) \left(1\right$ of type design spanning 400 years, serve as snapshots of complexity and contradiction, a framing device for the ${\ensuremath{\mbox{designer's}}}$ current surroundings.

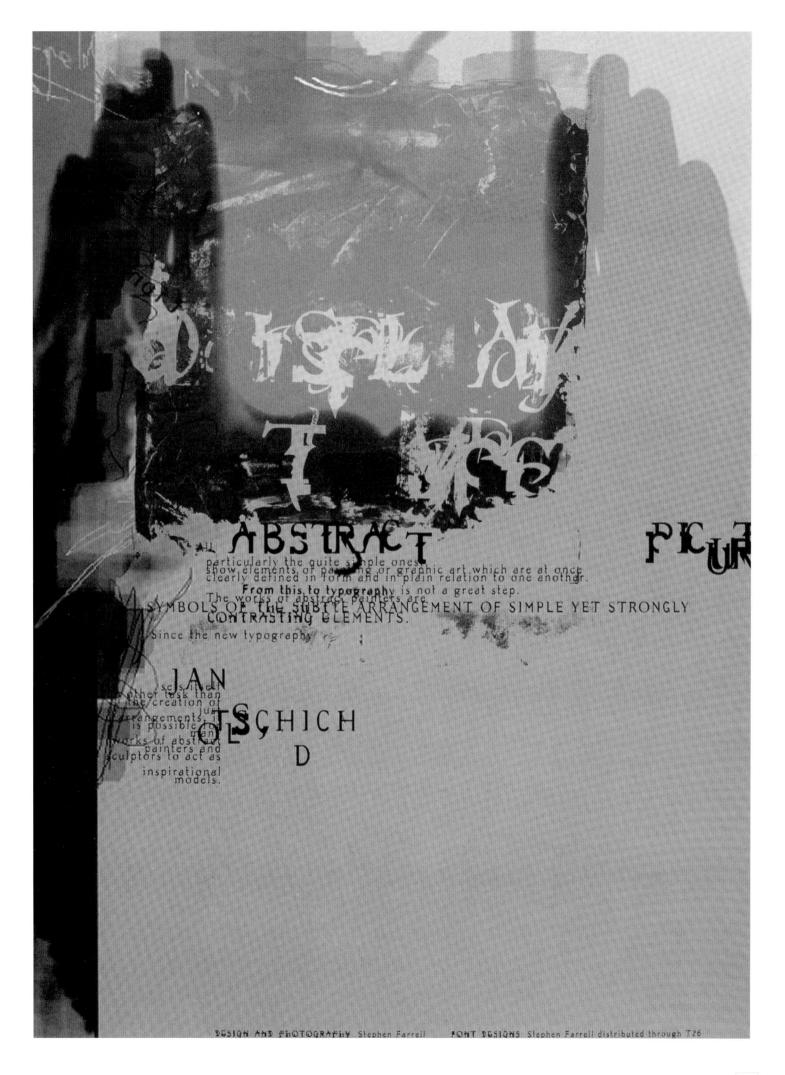

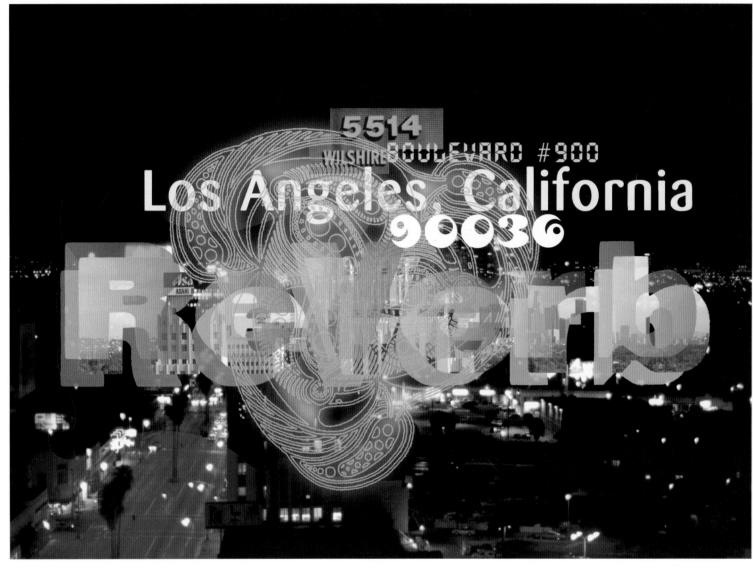

DESIGN Somi Kim for Reverb

PROJECT ReVerb postcard

T ○ ○ L \$ Adobe Photoshop, QuarkXPress on Macintosh

 $^{
m F}$ $^{
m N}$ $^{
m T}$ Unidentified American wood type, late nineteenth century

Type from **a variety of sources** was juxtaposed

to create a multilevel view facing downtown Los Angeles from the east windows of the studio. The font (known as Font Doe) was **originally hand set** and printed on a letterpress in an unidentified antique wood font purchased by Harvard's Bow and Arrow Press from Thomas Todd Printers, Boston.

DESIGN Masaki Fujimoto for Peter Piper Graphics

TOOL\$ Adobe Photoshop on Macintosh

FONT Peignot

This is the $\mbox{\sc lyric card}$ for the cd.

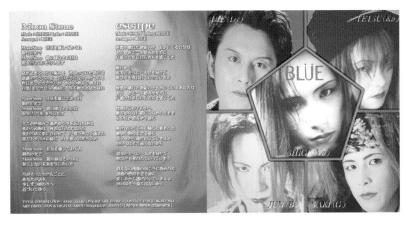

DESIGN Masaki Fujimoto for Peter Piper Graphics PROJECT Demo tape package design CLIENT Blue TOOL\$ Adobe Illustrator, Adobe Photoshop FONT Emigre Template

This work is designed for a music tape case.

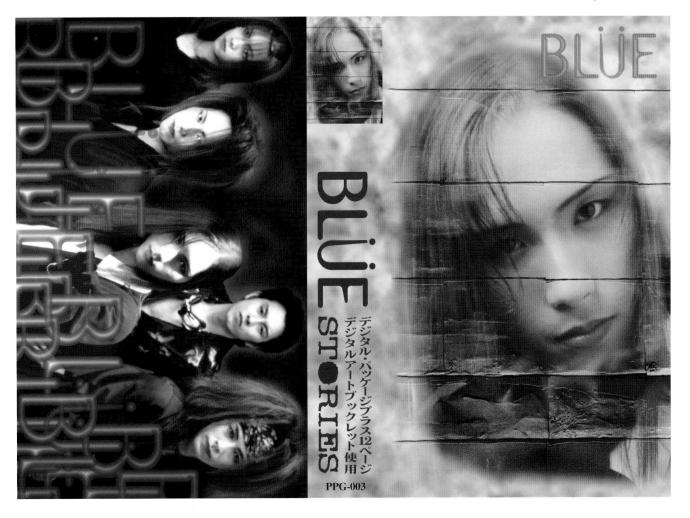

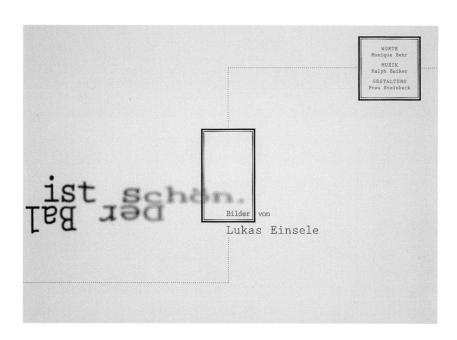

DESIGN Carolyn Steinbeck for Frau Steinbeck Design ркојест Die Welt ist schön. Der Ball ist rund сьтемт L.A. Galerie, Frankfurt, Germany TOOL\$ Adobe Photoshop, QuarkXPress on Macintosh FONT Prestige Elite

This project is an invitation to a **photography show.** The designer's loose translation of the project title is: "The world is beautiful. The ball is round." The second sentence is a quote from a famous German soccer coach that refers to the fact that a ${\tt soccer}\ {\tt ball}$ has its undeniable rules because of its roundness.

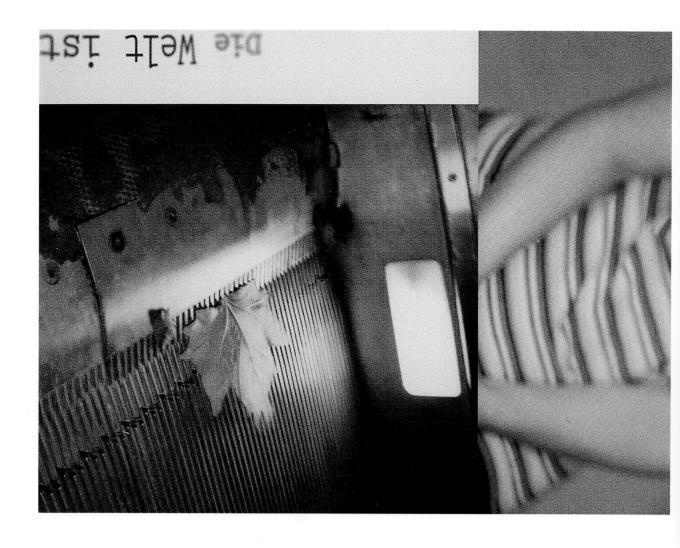

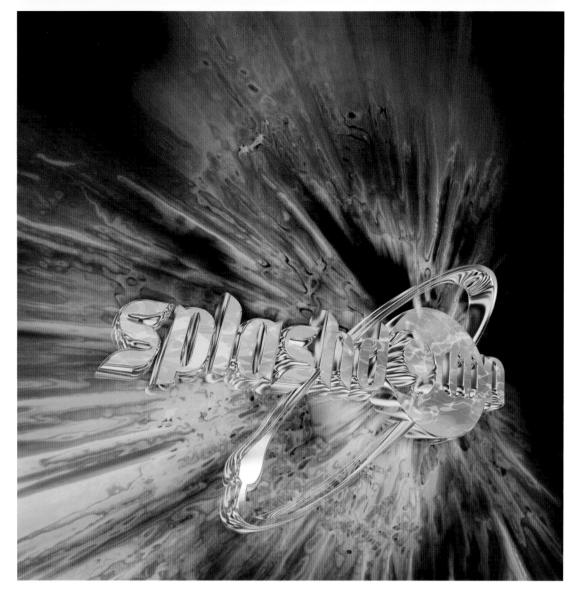

DESIGN Clifford Stoltze, Wing Ip Ngan, Richard Leighton, and Joe Polevy for Stoltze Design PROJECT Splashdown CD Stars and Guitars CLIENT Castle von Buhler (CVB) Records $^{ au\circ\circ L\,\$}$ QuarkXPress, Adobe Illustrator, Adobe Photoshop, Pixar Typestry on PC FONTS Baseline, Cyberotica, Isonorm

The Splashdown logo was initially developed with a ${\it custom font}$ as flat illustrator art and then made into a **3-D version** (used the front cover of the cd) in Pixar Typestry.

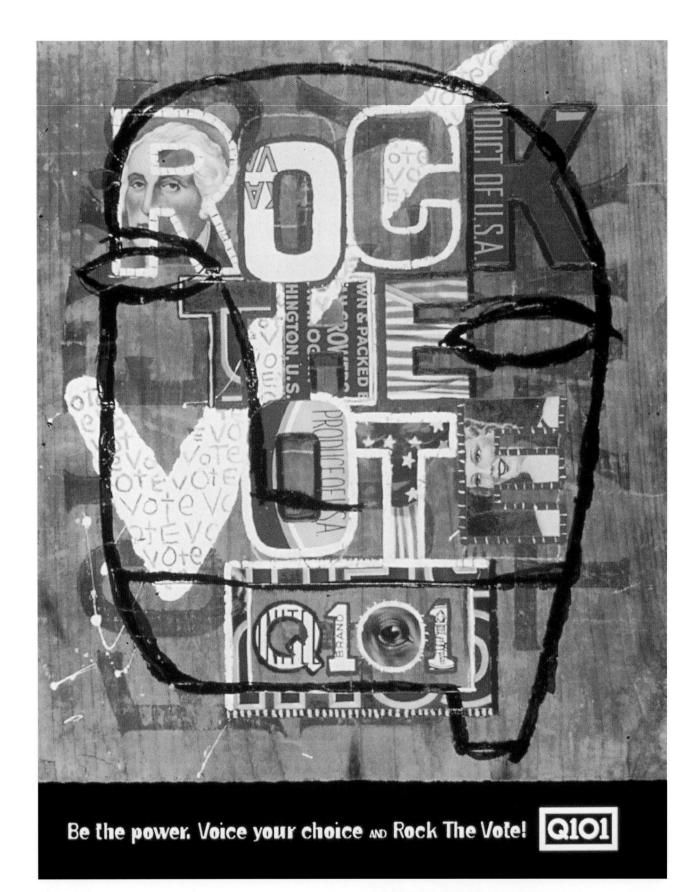

D E S I G N Laura Alberts for Segura, Inc.

PROJECT Rock the Vote

CLIENT Q101

[▼] ◇ [○] L ^{\$} QuarkXPress, Adobe Illustrator, Adobe Photoshop

FONT Colonist

Q101 Radio in Chicago is a sponsor for **Rock the Vote.**

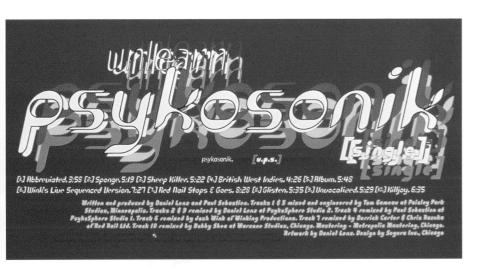

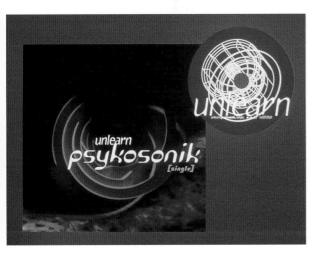

DESIGN Carlos Segura for Segura, Inc. PROJECT Psykosonik CLIENT TVT Records [†] ○ ○ L \$ QuarkXPress, Adobe Illustrator, Adobe Photoshop FONT Cyberotics, Truth

This is the **CD campaign** for Psykosonik.

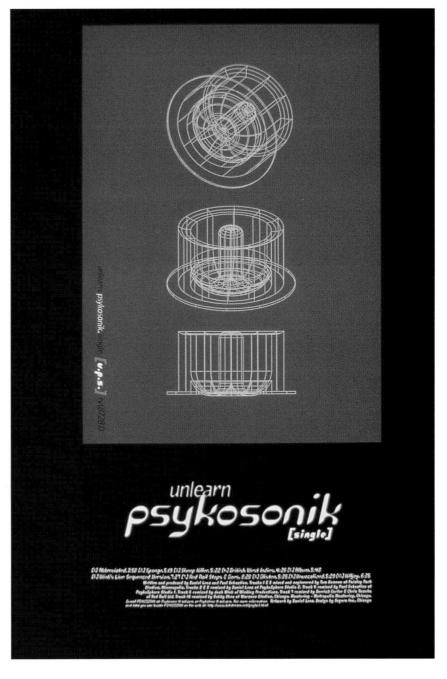

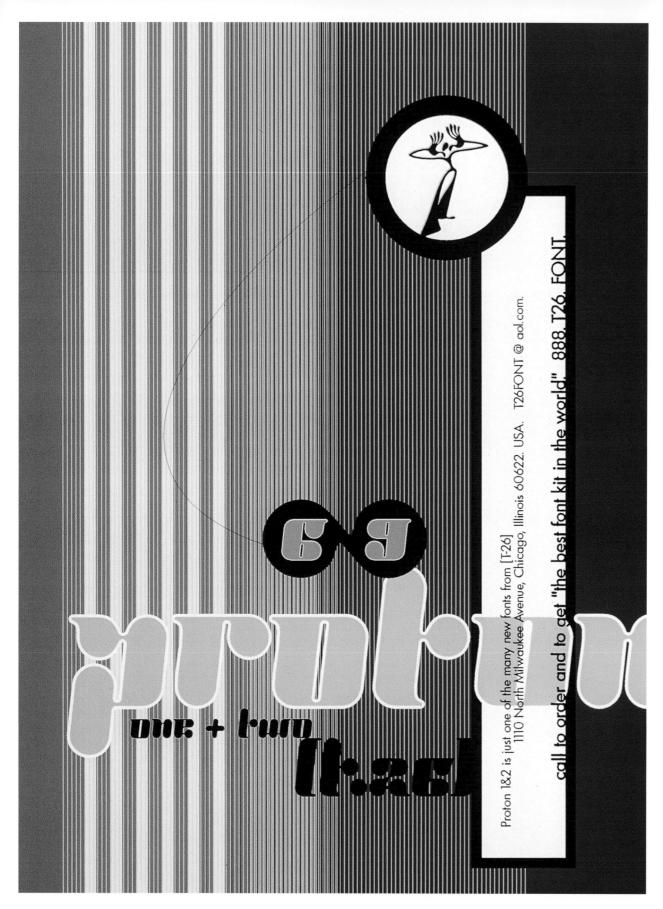

DESIGN Carlos Segura for Segura, Inc.

J € C T [T-26] mailer

QuarkXPress, Adobe Illustrator

FONT Proton

This is a postcard $\ensuremath{\textbf{promoting}}$ one of the type foundry's new releases called proton.

DESIGN Rick Salzman for re: salzman designs ст Ski/Abstr 4 advertisement TOOL\$ FreeHand on Macintosh

> The abstract shapes and copy suggest the freedom of downhill skiing and the need to take a chance by stepping out of the lines. The piece was created using client-provided photos, which were modified in Photoshop and composited in FreeHand.

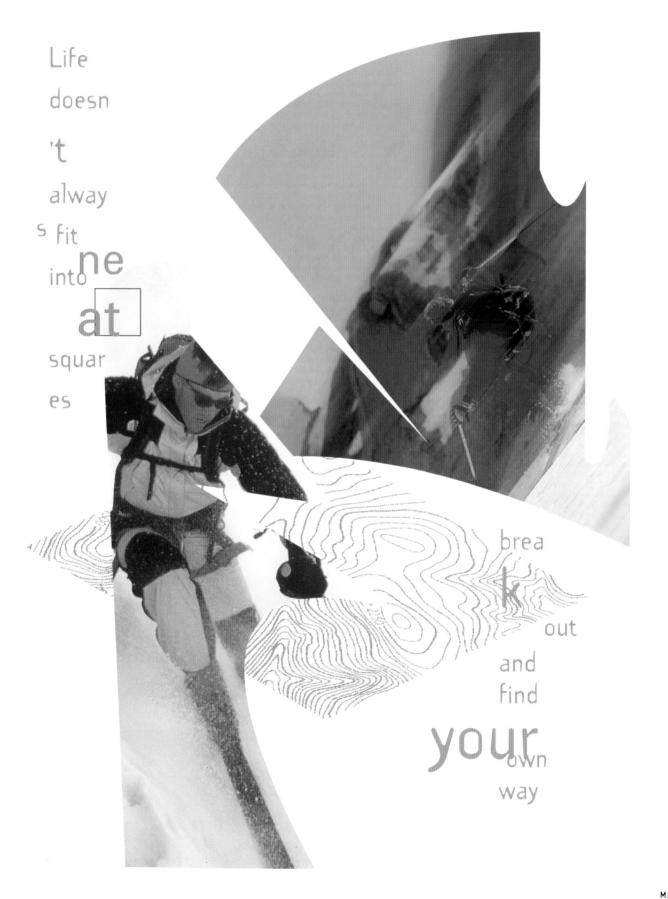

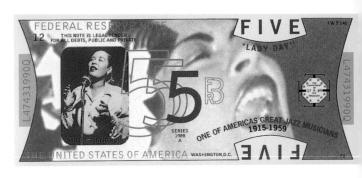

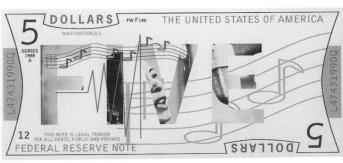

Blaine Todd Childers for Todd Childers Graphic Design Learning from Canyon Country Adobe Illustrator, Adobe Photoshop

> This is a student project created during the designer's $\mbox{\it graduate}$ studies at CalArts.

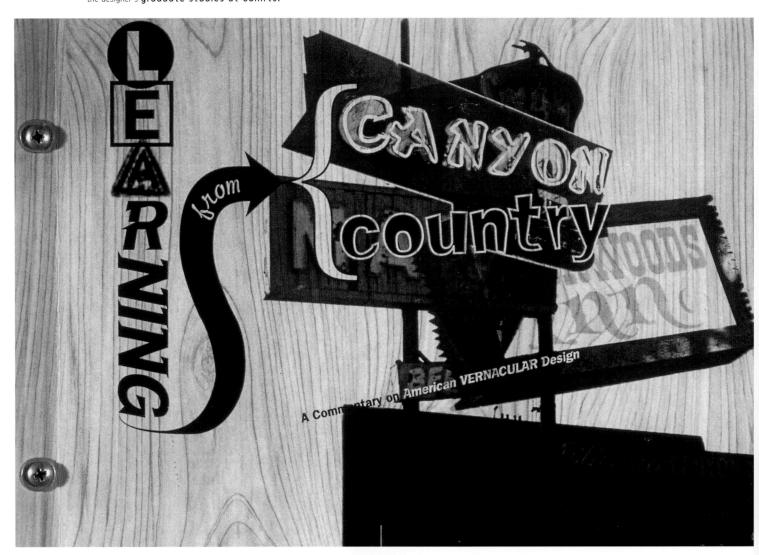

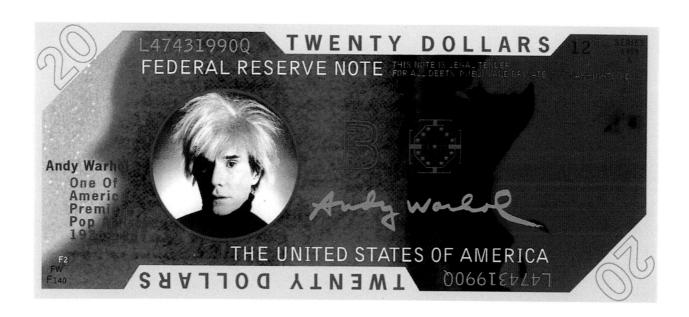

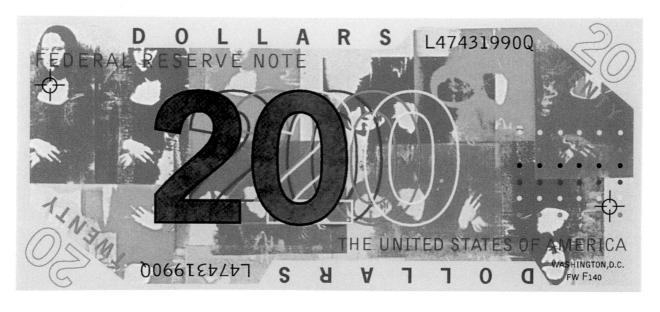

DESIGN James Stoecker

PROJECT Cal Arts M.F.A. thesis: \$20 and \$5 Bills

TOOLS FreeHand, Adobe Photoshop

FONTS News Gothic, Bell Gothic

Our currency is very old and lacks expressionism, fun, charm, and warmth. Color differentiation and form bring numerical heroes in the arts the acknowledgment they deserve and add to the fabric of American culture.

VI/71 is the middle of the 15th prioled words will not be VI/72 Gutenbergs first top mechanized process printing with moveable type. He will besign this face from German hand pritten letter forms. 31 Understand The digitalwill become the most Farm means of amministration offered brander decision making possibilities, fraditional motor made time made time made time made time to make the time to typeface important typeface for Chicago the beginnings of the mas was the sproduced, printed wor moveable Italian Renaissance will pe" of the adopt this mechanized MacIntoshprinting process and re computer quire different type faces, interface since the Gothic letter forms will be consider ed to be objectionable and hard to read. In Italy, mostly German printers who will flee their cou try due to political unrest, caused by the Reforma tion, will cut typefaces in le, which will serve the idea

DESIGN Carolyn Steinbeck for Cranbrook Academy of Art PROJECT Amerika mon amour or The Forbidden Fruit Adobe Illustrator, Adobe Photoshop, QuarkXPress on Macintosh Script Bold, Wittenberger Fractur, Joanna Italic, Chicago

This is a thesis project for the Cranbrook Academy of Art. The design of this thesis revolves around two statements. one is the Catechism of Influences, the other is a portion of the designer's thesis.

> VI/78 At the end of the second millennium wo/men looked at a rich past. They saw the mistake of their ancestors and thought that all problems came from dogmatic claims for Truth. They 图 图 130 图 图 图 图 图 图 图 150 came up with Sere the idea tha 图 图 图 3 am standing 图 图 图 图 图 图 图 图 139 there is n 3 cannot do Truth, an 图 图 图 图 图 13 created the 图 图 图 otherwise 120 ideology of "I'n OK, you're OK" 图 图 图 图 图 图 图 "Whatever and "A Place 图 图 图 图 图 for Everybody' Conscience Voice", Ther 图 was no place fo 四 图 图 图 图 disagreement 3n times when every berg, arguing against in their new bodn will be able to jus what he will understand 쩐 图 图 图 13 四 四 图 图 lest them in an tifn their individual act as wrong. The heart of his 原 图 图 图 图 图 网 图 were no one ions by purchasing mass belief will be the doctrine 图 图 图 图 图 right, nothing produced indulgences, wh of Justification by Faith. was bad of ich contribute to the goals What will be meant as an 图 图 图 图 图 图 图 四 图 of the leading ideology, encouragement for dis 图 图 图 图 四 图 图 图 떱 B started to voices will arise rement cussion, will cause wars re-form 图 13 图 图 图 图 图 网 图 图 图 re-create, and bering values of the past. and the reformation of re-construc lost truths Martin Luther will strug the existing belief sps 四 图 图 图 The only other gle with the rightness of tem. Mann followers of world they could 图 图 图 13 图 图 13 have escaped his belief, and never come this movement will flee 图 图 图 四 图 virtual world to a satisfying conclusion. at first the country and a world that seemed to re-But he will not be content later the continent. No 图 图 图 图 图 main foreign because of its with the practice of the Ro threat will break Luthers 图 图 untouchability man church and will post conviction, and he will be 图 图 四 图 图 图 95 theses at the castle condemned by the papacy. church door in Witten 要 8 When ignorance ends, personal judgement evaluates new knawledge (>1/1 Anowiedge) Acting by applying force (>V/63 Force) triggers change (>VI/80 Change) of an

and forms (>VI/71 Forms) opinions and buths (>IV/47 Truth). To act in accordance with one's own conduct is a sense which can be suppressed, but will result in estrangement (>III/34 Estrangement) of the self.

existing condition. Action has to imply responsibility to one's understanding (>VI/72 Understanding) of truth (>IV/47 Truth), because even If not apparent, each action influences reality (>VI/73 Reality).

AMERIKA mont

The Forbidden Fruit

(Frau Steinbeck's Platitudes, inspired by Luther's 95 Theses)

An everyday dictionary of steadily asked and
never really answered questions

aks ef e npg

answering

Questions about

Definition Balue Perfection Greatness

Goul

Destinn Force

Companion

Context Gensation

Berformance

Present

Seduction Pleasure

V.
Catechism of Women and Men

incl. Platitudes 57:70

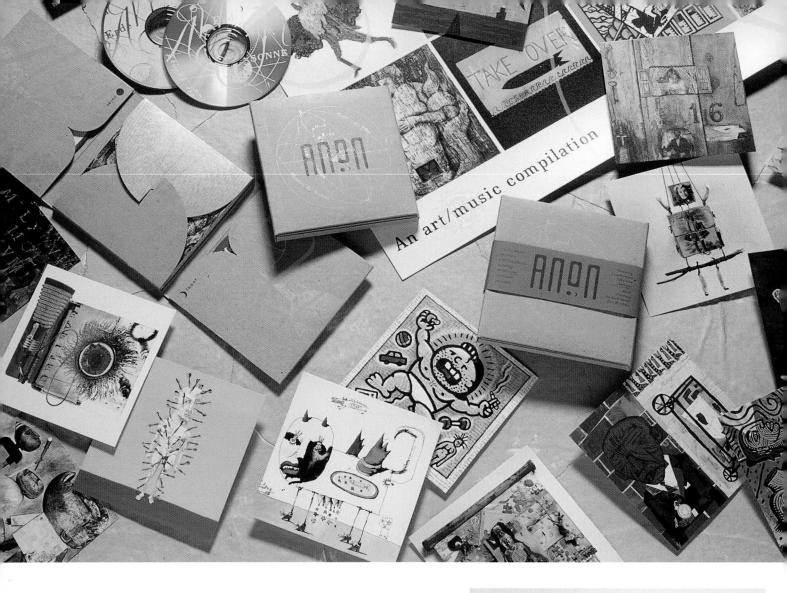

DESIGN Clifford Stoltze for Stoltze Design Anon compilation CD and poster CLIENT CVB Records

The Anon logo is a **slightly modified** version of an unreleased typeface called Gangly, designed by Joe Polevy. The script font was first set on the computer using the font Amazone and then ${\tt photocopied}$ to ${\tt give}$ it ${\tt a}$ hand-drawn effect. Calvino, designed by Elliot Earl, was used for the text.

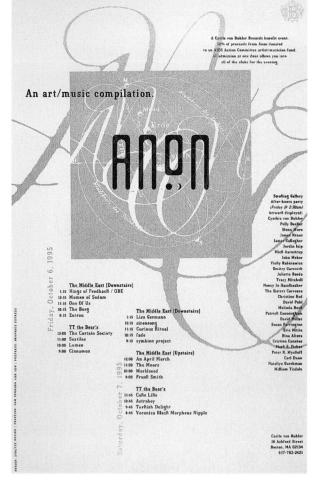

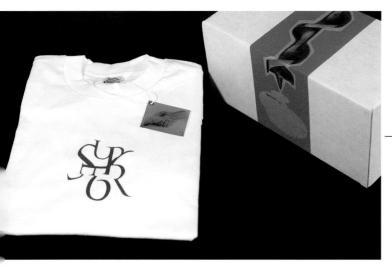

DESIGN Doug Bartow ркојест Super 6 promotional mailer TOOL\$ Macintosh FONT Trajan

This is a promotional piece designed for direct mail. The image of the handshake, which was ${\it screen printed}$ onto ${\it aluminum flashing}$, is a metaphor for an introduction.

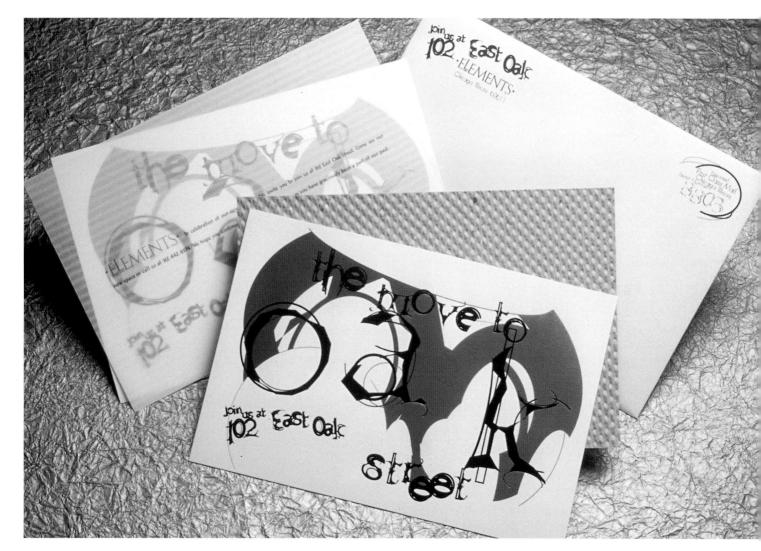

DESIGN Carlos Segura for Segura, Inc. $\mathbf{E} \circ \mathbf{T}$ Elements relocation project CLIENT Elements TOOL\$ QuarkXPress, Adobe Illustrator

FONTS Finial, Futura

These moving announcements for a retail store played on their new address, Oak Street, and therefore were silkscreened on oak.

Please join us or the opening celebration the exhibition

Walker Art Center

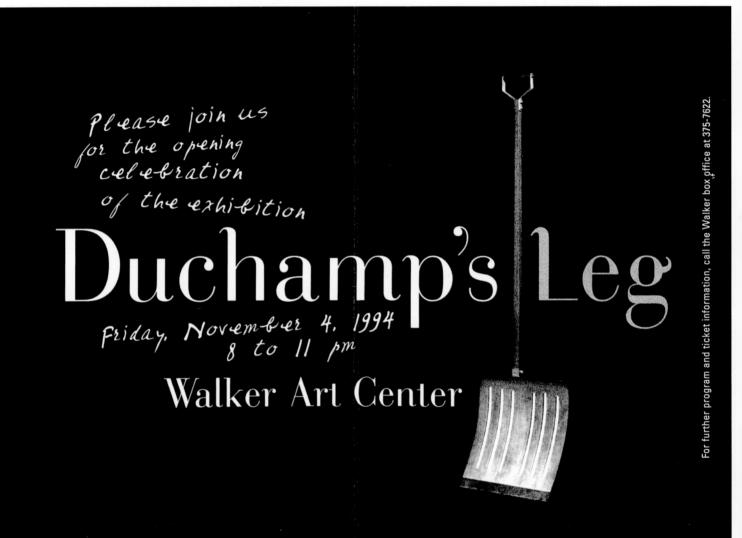

Matt Eller for Walker Art Center

Typeface

Fontographer on Macintosh

Bauer Bodoni

This is a typeface developed in conjunction with Duchamp's Leg, an exhibition examining Marcel Duchamp's continuing influence on subsequent generations of artists. An equally stoic Bodoni has now been defaced, albeit cutely.

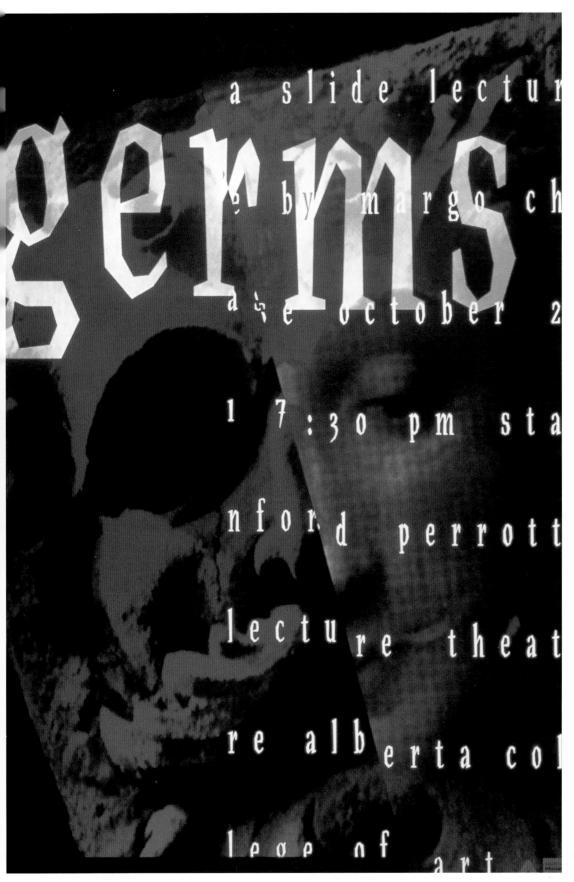

D E \$ 1 G N Margo Chase for Margo Chase Design TOOL\$ Fontstudio FONT Bradley

> Designed with no curves at all, this font was inspired by Czech woodcut typefaces. It's condensed in its original form, but because of the lack of curves, it "extends" well to create new styles.

Carlos Segura for Segura, Inc.

PROJECT Alternative Pick

Alternative Pick

TOOLS QuarkXPress, Adobe Illustrator

BOXSpring, Mattress

This is the 1996 version of the Alternative Pick, a sourcebook from New York.

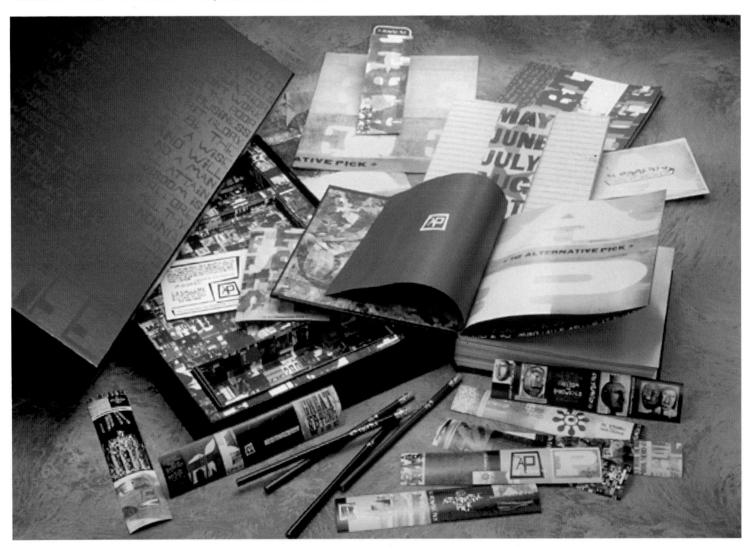

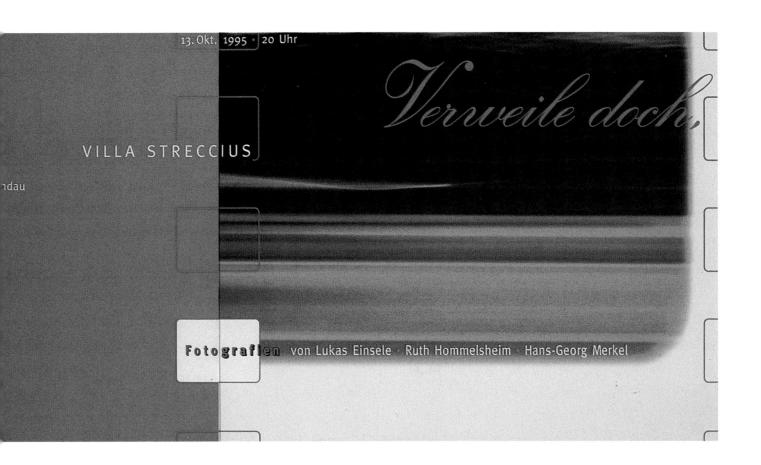

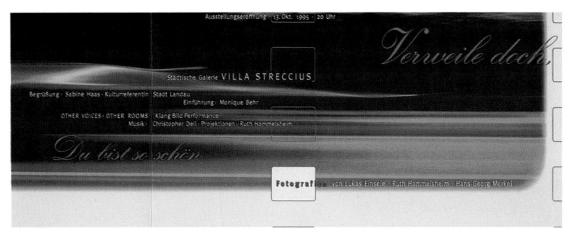

DESIGN Carolyn Steinbeck and Alexandra Schettler for Steinbeck-Schettler €¢ T Verweile doch, Du bist so schön ENT Gallery Villa Strecclus, Landau, Germany TOOLS Adobe Photoshop, QuarkXPress on Macintosh FONTS Künstler Script, Officina

The project was an invitation to a photography show.

The project title roughly translates to, "Linger, you are so beautiful."

DESIGN Margo Chase for Margo Chase Design

TOOL\$ Fontographer

FONTS Box Gothic

Box Gothic was inspired by 1980s Japanese design.

The letters all fit into the ${\tt same}$ proportion box.

There are no curves and only vertical horizontal lines.

D E \$ 1 G N Margo Chase for Margo Chase Design TOOLS Fontographer FONT * Trajan, OCR

This font was desinged to look like badly printed or decayed Roman titling to make a traditional typographic treatment on a CD cover look both **old and contemporary.**

It was created using the "blend fonts" filter in Fontographer and then reworked by hand.

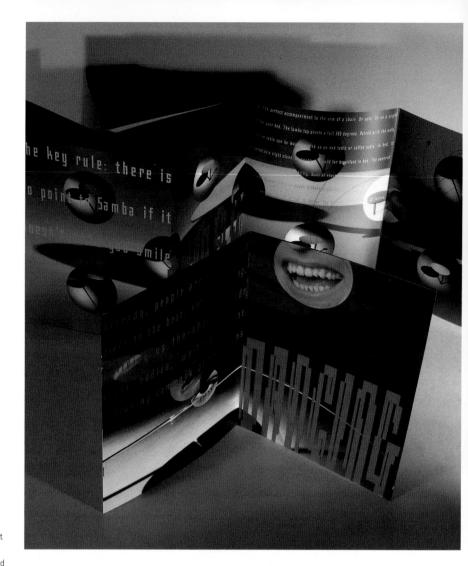

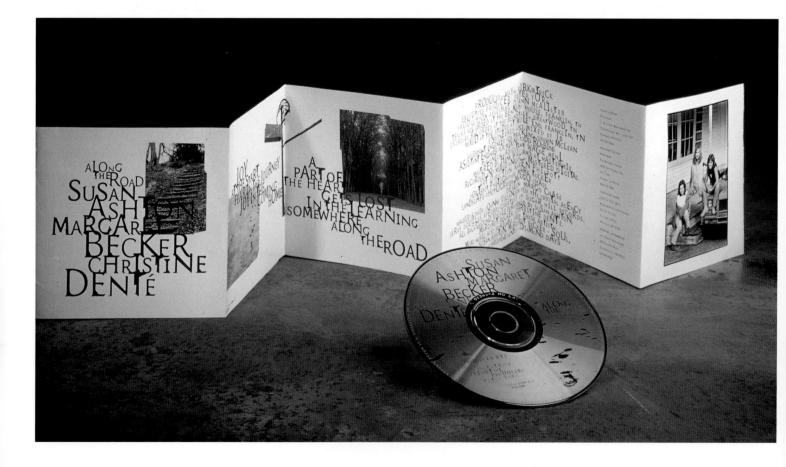

DE\$1GN Shuichi Nogami for Nogami Design Office

CLIENT Inoue Paper Co., Ltd.

 $^{\text{T}}$ $^{\circ}$ $^{\circ}$ L $^{\circ}$ Adobe Illustrator on Macintosh

FONTS Franklin Gothic Demi

[&]quot;Float" was printed using a **heat treatment process**, and no ink was necessary.

POETRY

PUAL AIR FRESSURE

MODIFIES THE PROSURE OF THE AIR TO MATCH THE MOVE MENT AND IMPACT OF

YOUR HOUT

YOUR HOUT

WITHIN THE SHOE TO WHERE YOUR BODY NEEDS

IT THE MOST FOR EACH ACTIVITY

YOU'RE RUNNING THE LOWER DENSITY 5 PS1

AR MAG IS FLACED AT THE CONTROL OF A RANGES FLACED AT THE CENTER OF YOUR HELL AND WHEN YOUR FOOT LAMBS.

DENSITY AIR BAG THE 25PS I HIGHER WHAPS ARO UND THE HELL PRANCESS AND STABILITY THE AIR IN THE CHAMBER IS ACTUALLY. A GAS WITH LARGER HOLECULES IT WILL NOT DEHATE OVER THE CHARGE OF THE CHARC

TEMPERA TURE

[MOTION]

MAX2

Doug Bartow

P R ◇ J E ≎ T Nike AirMax2 advertisement series

TOOL\$ Macintosh

The designer used the provided digital imagery to create three layouts that present a series of dichotomies for the three separate layouts: art/science, poetry/motion, and truth/knowledge.

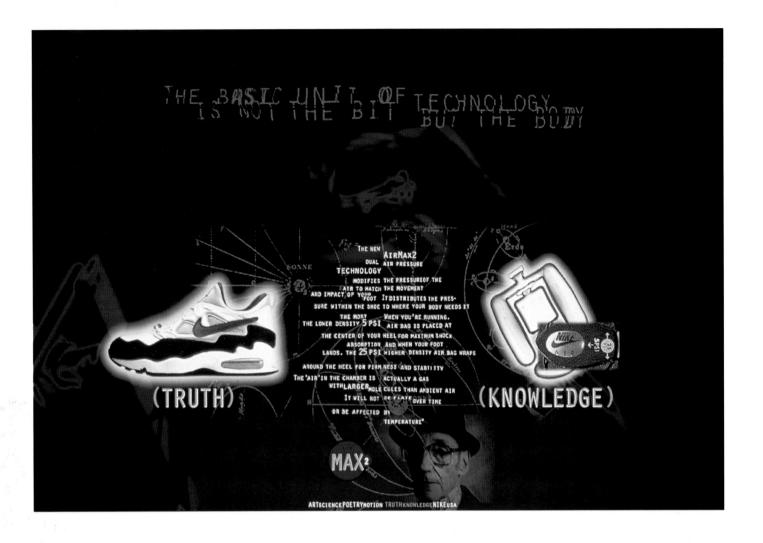

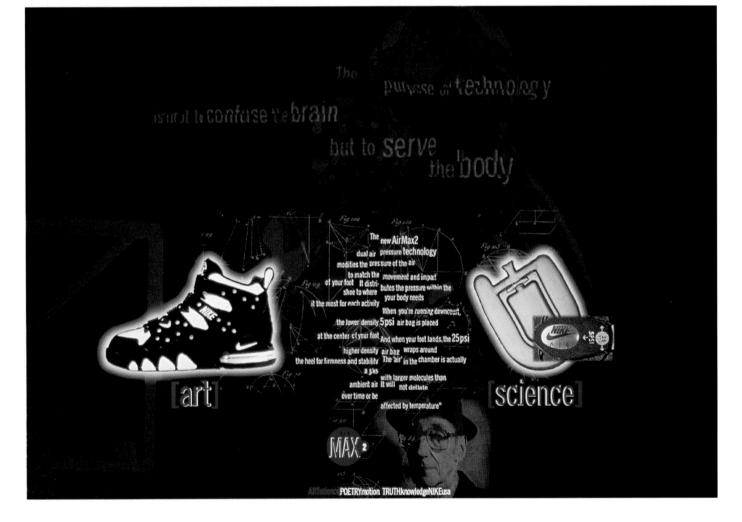

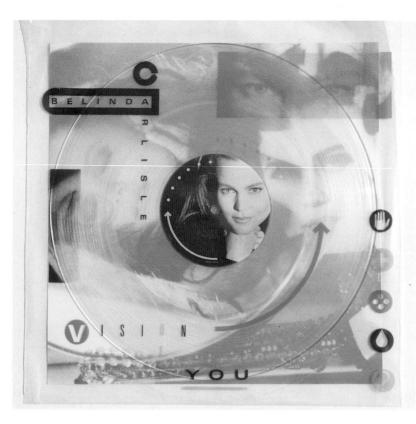

DESIGN Norman Moore for Design Art, Inc.

PROJECT Belinda Carlisle—Vision of You

CLIENT Virgin Records

TOOLS Adobe Photoshop, QuarkXPress, FreeHand on Macintosh

PONT Univers

This is a **12-inch vinyl music package**, including a transparent disc and a transparent vinyl silkscreened bag.

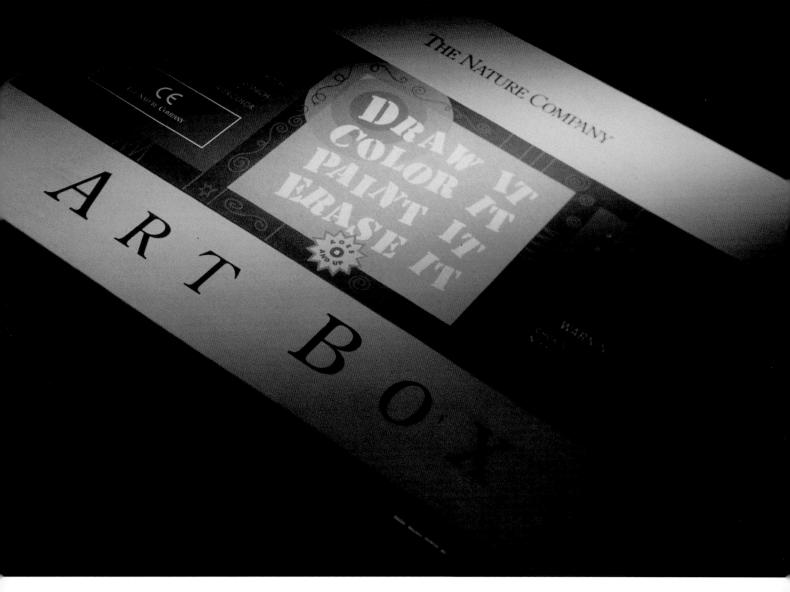

DESIGN
Mark Sackett, Wayne Sakamoto, James Sakamoto for Sackett Design Associates

PROJECT
The Nature Company Art Box

CLIENT
TO LS
QuarkXPress, Adobe Illustrator, Adobe Photoshop on Macintosh
FONT
Stencil

This box of art supplies for children needed to be **repackaged with a simple label** that could be **hand applied to each box**. The type was rotated at different angles.

Filters were also used to create **transparency in the design**.

DESIGN
James Stoecker and Margo Johnson
PROJECT
CalArts Arts: Visiting Artist Program
CLIENT
CalArts Art Department
TOOLS
FreeHand, Fontographer
James Stoecker's Font: Mansonic

The image in the background is so complex that it required a more structured approach to the type. Playful but classic, the cross shapes echo from image to text.

Doug Bartow 87 Marshall Street North Adams, MA 02147

CARE Communications 151 Ellis Street NE Atlanta, GA 30303

Charles Carpenter Design Studio 2501 Foothill Boulevard #3 La Crescenta, CA 91214

> Depke Design 1492 Furnleigh Lane Chesterton, IN 46304

Design Art, Inc. 6311 Romaine Street #7311 Los Angeles, CA 90038

Giana Illustration and Design 17 Colonial Drive Simsbury, CT 06086

> Graphic Art Studio Via San Vincenzo, 26 80053 C/MMARE Di Stabia Italy

Frau Steinbeck Design Friedelstrasse 40 12047 Berlin Germany

FUSE, Inc. 483 Moreland Avenue NE, #4 Atlanta, GA 30307

> Hans Flink Design, Inc. 224 East 50th Street New York, NY 10022

International Events 1919 Menalto Avenue Menlo Park, CA 94025 Kan Tai-keung Design and Associates, Itd. 28/F Great Smart Tower 230 Wanchai Road Hong Kong

Kelly Brother Illustration 5250 Sycamore Grove Memphis, TN 38120

Deborah Littlejohn 4130 Blaisdell Avenue South Minneapolis, MN 55403

Malcolm Turk Studios 16 Abingdon Square 2C New York, NY 10014

Margo Chase Design 2255 Bancroft Avenue Los Angeles, CA 90039

Matteo Bologna Design NY 142 West 10th Street #2 New York, NY 10014

Mike Salisbury Communications 2200 Amapola Court Suite 202 Torrance, CA 90501

Mires Design, Inc. 2345 Kettner Boulevard San Diego, CA 92101

Miriello Grafico, Inc. 419 West G Street San Diego, CA 92101

Nogami Design Office 5-7-14-103, Nishinakajima Yodogawa-ku, Osaka 532 Japan

Pentagram Design 204 Fifth Avenue New York, NY 10010

SLIP 4820 North Seeley Avenue Floor 3 Chicago, IL 60625

Peter Piper Graphics 501 Green-Heights Moriguchi-City, Osaka, 570

Steinbeck-Schettler 1-7 Midori-Machi Friedelstrasse 40 12047 Berlin Japan Germany

PJ Graphics 4223 Glencoe Avenue #C-203 Marina del Rey, CA 90292

Stoecker, James 740 16th Avenue Lenlo Park, CA 94025

re: salzman design 293 Rabideau Street Cadyville, NY 12918

Stojan Pekel 32 62211 Pesnica Slovenia

Rebeca Méndez Design Those People 1023 Garfield Avenue South Pasadena, CA 91030

Stoltze Design 49 Melcher Street Fourth Floor Boston, MA 02210

Red Rockett Design 124 W 24th, Suite 5-D New York, NY 10011

The Apollo Program 82 East Elm Street Greenwich, CT 06830

ReVerb 5514 Wilshire Boulevard #900 Los Angeles, CA 90036

Todd Childers Graphic Design 130 North Grove Street Bowling Green, OH 43402

Robert Bak 76-200 Stupsk Witosa 6/45 Poland

Sander van Baalen INA Boudier Bakker Laan 15-2 3582 VB Utrecht The Netherlands

Sackett Design Associates 2103 Scott Street San Francisco, CA 94115

Visual Dialogue 429 Columbus Avenue #1 Boston, MA 02116

Segura, Inc. 1110 North Milwaukee Avenue Chicago, IL 60622

Walker Art Center Vineland Place Minneapolis, MN 55403

ndex

Art Center Design Office 82-83 Bartow, Doug 11, 131, 138-139 CARE Communications 98-99 Charles Carpenter Design Studio 48 Cranbrook Academy of Art 128-129 Depke Design 50 Design Art, Inc. 11, 79, 140 Frau Steinbeck Design 120 FUSE, Inc. 110, 111, 112 Giana Illustration and Design 69 Graphic Art Studio 60 Hanegraaf, Andre 106-107 Hans Flink Design, Inc. 68 International Events 64-65 International Events 64-65 Johnson, Margo 140 Kelly Brother Illustration 109 Littlejohn, Deborah 23, 41, 72, 84-85, 113 Malcolm Turk Studios 86, 87 Margo Chase Design 104, 114, 133, 136 Matteo Bologna Design NY 52-53, 61, 62-63 McKinney, Shawn 72 Mike Salisbury Communications, Inc. 48, 51, 55, 66, 73, 92-93 Mires Design, Inc. 49, 54, 55, 57, 60, 74, 75 Miriello Grafico, Inc. 100 Nogami Design Office 14, 16, 17, 18, 19, 32, 33, 42, 43, 137 Pentagram Design 24-25, 26, 58-59, 78-79, 88-89, 90-91 Peter Piper Graphics 119 PJ Graphics 51 re: salzman designs 10, 125 Rebeca Méndez Design 20-21, 35, 95 Red Rockett Design 108 ReVerb 118 Robert Bak 15 ROM Graphixxx Milano 52-53 Sackett Design Associates 141 Segura, Inc. 15, 67, 69, 94, 122, 123, 124, 131, 134 SLIP 76-77, 116, 117 Steinbeck-Schettler 135 Stepp, Shelley 41 Stoecker, James 34, 44, 45, 127, 140 Stojan 107 Stoltze Design 22, 38-39, 80-81, 96, 97, 101, 121, 130 The Apollo Program 28-29, 30-31 Todd Childers Graphic Design 27, 40, 105, 126 van Baalen, Sander 106-107 Visual Dialogue 36-37, 56, 115 Walker Art Center 132